星の辞典

柳谷杞一郎

宇宙は膨張している。

この衝撃的な事実を発表したのはアメリカの天文学者ハッブルである。彼は「遠いところにある銀河ほど、速いスピードで遠ざかる」ということを発見したのだ。もちろん、太陽と地球は強い重力で引きあっているので、その距離が大きくなることはない。恒星間の距離にも変化は起こっていない。遠ざかっていくのは銀河同士である。

だとすれば、遠い昔の宇宙は、限りなく小さかったということになる。宇宙がほんの小さな火の塊だったのは約138億年前だったと考えられているのだ。この小さな火の塊(超高温、超高密度)が大爆発して宇宙は始まったのだと説明する理論をビッグバン宇宙論

## Foreword

とよぶ。そして今も、宇宙は膨張を続けている。

この小さな火の塊はどのようにしてきたのか、小さな火の塊ができる前はどんな状態だったのか、膨張する宇宙の外側にはなにがあるのか。疑問がつきることはないが、正解を導きだすことは現時点では不可能といっていいだろう。

ともかく宇宙は誕生したのである。急膨張ののち、緩やかな膨張に転じる。宇宙を自由に飛び回っていた電子は原子核にひきつけられ原子を構成する。やがて水素を主成分としたガスや塵が重力によって集まり、密度と温度をあげていく。核融合反応がはじまると大きな光と熱を発する恒星が誕生。夜空

に美しい星たちが輝きはじめたのである。最初の星が生まれたのは宇宙誕生の約2億年後。太陽系が生まれたのは今から約46億年前。地球に原始生命が生まれたのは約40億年前とされている。人類の祖先が地球上に現れ、宇宙の不思議を解明しはじめたのはつい最近のことでしかない。ただ、テレビもラジオもインターネットもない時代、星空の美しさを愛でることは、どんなエンターテインメントよりも人々の心をふるわせたに違いない。また、星空を観察し、時間の経過や方角を知ることは、直接生活の利便性にもつながっていたのである。

系が位置する銀河はその中でも比較的小さな銀河だが、それでもおよそ2000億個の恒星で構成されている。米粒一つが星だとすると2000億個の米粒は小学校のプール（25×12×1・2m）15杯分にもなるのだ。宇宙には、それこそ気の遠くなるような数の星たちが燃焼し続けているのである。

現代においても夜空で輝く星々は人々の心をふるわせる存在である。

星を愛で、星を知り、星を語り、星と対話する。本書がその一助となればこれ以上の喜びはない。

数千億個の恒星で構成される銀河は宇宙に1000億個以上存在する。太陽

| | |
|---|---|
| 星 | 027 |
| 春 | 056 |
| 夏 | 088 |
| 秋 | 118 |
| 冬 | 148 |
| 南天 | 174 |

Contents

宇
193

月
237

はじめに 002
参考文献・クレジット 287
おわりに 280
索引 282

星

*Dictionary*

*of the star*

## 星座の成り立ち

遠い昔、夜空を眺めることは、人々にとって大きな歓びであっただけでなく、生活の利便性に直接つながっていた。星や月を注意深く観察していれば、暦をつくること（季節の移ろいや方角を知ること）、時間の経過や方角を知ることができる。5000年前の羊飼いや船乗りたちは、読み書きはできなくても、星空の不思議を知る必要があったのだ。古代において、天文学者は間違いなく最高級、最先端の知識人だったのである。

星空の知識をより多くの人々に伝えるためには、特徴的な並びの星々に、具体的なイメージを与えた方がいい。神話の中に登場する英雄や動物になぞらえれば、より効果的である。こうして星座は誕生した。歴史上最初に星座が登場するのは古代エジプトである。

エジプトでは紀元前3000年にはかなり正確な暦が存在していたという。紀元前6世紀の古代バビロニアでは天体観測がより重要視され、太陽の円軌道上にある12の星座に名前をつけ、黄道十二宮とする。

エジプトやバビロニアの星に関する知識は、やがて当時最先端の文明をもっていたギリシアに受け継がれ、大きく変貌していく。天文学に哲学と科学が融合していくのである。

紀元前2世紀の学者ヒッパルコスは、850の星に光度による等級をつけて星図をあらわした。

それから約300年後、紀元前2世紀半ばにプトレマイオスが登場し、ヒッパルコスの星図を増補改訂し、1022の天体からなる新星図を発表する。ここには、現在にまで伝えられる48の星座が記されている（17世紀初頭に至るまで変更されなかった）。ちなみに中国でも紀元前1000年ころには暦がつくられるようになっており、紀元前5世紀の時点で、確認されていた星の数は1464、定められた星座の数は284にもおよんだという。

8〜9世紀にイスラム文化は隆盛期を迎えた。イスラム文化においても、暦、時間、方角は最重要事項である。プトレマイオスの著作はアラビア語に翻訳され、イスラム天文学は飛躍的な発展を遂げ、ヨーロッパ天文学を凌駕する。

このため、現在使われている星の名はギリシア起源のものよりもアラビア起源のものの方が圧倒的に多くなっている。16世紀は大航海時代の幕開けである。船乗りたちは、航海の途中、いままで目印にしていた星たちを見失い、今まで目にしたことのなかった星たちと出会うことになった。こうしてプトレマイオスの48星座に1500年ぶりに、南半球の12の星座が加えられることとなる。その後、多くの天文学者が勝手気ままに新星座を増やしたため、混乱が生じた。そこで、この混乱した状況を解決するべく1920年に国際天文学連合が結成され、1930年の総会で88の星座を定めることとなったのだ。

## 季節の星座があるわけ

星はいつも同じ場所で輝いているわけではない。時間によって、季節によって、星はその輝く場所を変えていく。まるで、動いているように見えるはずだ。でも、輝く星が動いているわけではない。動いているのは地球の方だ。

地球は1日に1回、自転する。だから、夜空の星たちは地球の自転と逆方向に動いているように見える。これを星の日周運動とよぶ（1時間に15度ずつ東から西に移動する）。また星は季節によっても見える位置が変わる。地球から見えるのは太陽と反対方向にある星だからだ。地球は1年をかけて太陽の周りを1周する。だから、夏にしか見えない星、冬にしか見えない星が存在することになる。これを星の年周運動とよぶ（1か月に30度ずつ東から西に移動する）。

ほかにも、地球の自転軸が勢いのおとろえたコマの心棒のようにゆっくりと小さな円を描きながらずれていく。これを歳差運動（2万6000年の周期）とよぶ。このため、北極星の役割を果たす星は次々に交代していくのである。

## シリウス
### Sirius

大犬座のシリウスはマイナス1・5等級。全天一の明るさを誇る。地球からの距離はわずかに8・6光年。近いからこその明るさともいえる。それでもその実際の明るさは太陽の40倍、表面温度は1万度、直径は1・8倍もある。シリウスは有名な二重星で、伴星のシリウスB（白色矮星、8・5等級という暗い星である）は1862年に発見された。燃料である水素をほとんど使い果たし死にゆく段階にある。今は収縮による余熱で輝いているのだ。質量は太陽と同じくらいなのに、直径は地球とほぼ同じくらい。角砂糖一つの大きさで百数十kgにもなる。

## カノープス
### Canopus

竜骨座のカノープスはマイナス0・7等級。全天で2番目に明るい黄色の巨星である。地球からの距離は309光年。したがって、実際にはシリウスよりもずっと明るい星だということになる。質量は太陽の約9倍、直径は65倍、明るさは1万5000倍程度と考えられる。赤緯マイナス52度に位置するため、日本からだと地平線ぎりぎりのところでしか観察することができない。大気の影響により、減光され赤く暗い星に見える。

シリウス

カノープス

033
032

## アルクトゥルス
*Arcturus*

牛飼座のアルクトゥルスはマイナス0.0等級。全天で4番目の明るさをもつ。オレンジ色に輝く星である。直径は太陽の26倍、質量は約20倍と考えられている。地球からの距離は37光年。日本でも麦秋（6月の麦刈りの始まる頃）に頭上に輝くことから、麦星の名で親しまれてきた。動きが速い星（秒速125km。東京大阪間をわずか4秒で駆け抜ける）としても知られている。乙女座のスピカ方向に移動しており、6万年後にはスピカに並ぶ。それでも、見かけ上満月の直径分動くのに800年の歳月が必要とされるという。

アルクトゥルス

035
034

カペラ

*Capella*

 馭者座(ぎょしゃ)のカペラは0・1等級。全天で6番目に明るい。カペラは「小さな牝山羊」の意。表面温度は太陽と同じくらいなので、色も太陽に似た黄色である。赤緯46度で、1等星としてはもっとも北に位置する。北海道あたりからだと1年中いつでも見ることができる。この星は連星で、二つの黄色巨星(0・9等級と1・0等級)が104日周期で回りあっている。二つの星の間は太陽と金星の距離(約1億km)ほどしか離れておらず、一般の望遠鏡では二重星であることを確認することはできない。地球からの距離は43光年。

# プロキオン
## Procyon

小犬座のプロキオンは0・4等級。全天で8番目に明るい。地球からの距離はわずか11光年。1等星ではケンタウルス座のリゲル・ケンタウルス、大犬座のシリウスについで近いところに位置している。
この星もシリウス同様に二重星で、白色矮星（10等星）をともなっている。二つの星は、太陽と天王星の距離をおいて40・7年周期で回っている。伴星の質量は地球の約20万倍だが、直径は地球よりもやや大きい程度。超高密度で角砂糖1個の大きさは、2tを超える重さとなる。星としての寿命はほぼつきかけている状態である。

## リゲル
### Rigel

オリオン座のβ星リゲルは0・1等級。全天で7番目の明るさをもつ青色巨星である（馭者座のカペラも0・1等級）。日本では「平家星」と対をなすものとして「源氏星」とよばれる。地球からの距離は863光年。太陽の70倍の大きさがある上に超高温（1万度以上）で、実際の明るさは太陽の4万倍と考えられている。琴座のベガと同じ位置（25光年）にあったとしたら、マイナス7等級もの明るさに見えることになる。自転速度も秒速400kmを超え、ちぎれんばかりの超ハイスピードで回転している。この星も二重星（伴星は6・8等級）である。

## ベテルギウス
### Betelgeuse

オリオン座のα星ベテルギウスは0・4等級から1・3等級まで不規則に変光する赤色超巨星である。日本では「平家星」とよばれる。地球からの距離は497光年。直径は太陽の約650倍にもおよぶ。かなり年老いた星で、輝くためのメカニズムが不安定で変光しているのだと考えられている。放出された塵やガスの雲に包まれていて、今も膨張を続けている。やがては超新星爆発を起こし、牡牛座のカニ星雲内に存在するような中性子星をつくることになるだろう。爆発のときには、マイナス7等星くらいの明るさで夜空に輝くと推測されている。

ベテルギウス

リゲル

039
038

## リゲル・ケンタウルス
### Rigil Kentaurus

ケンタウルス座のα星リゲル・ケンタウルスはマイナス0・3等級。全天で3番目に明るい黄色い星である。地球からの距離はわずか4・3光年。地球にもっとも近い恒星である。この星は現在太陽系に近づきつつあり、1万8000年後には3・1光年まで接近。マイナス1等星としてシリウスにつぐ存在となり、夜空に輝くことになる。また、この星は三重星としても知られており、主星は太陽と同じ程度の大きさ、伴星の一つは主星から0・29光年離れたところを約100万年の周期で回っている。ちなみに伴星の方がより地球に近いところに位置している。

## アケルナル
### Achernar

エリダヌス座のアケルナルは0・5等級。全天で9番目に明るい。赤緯はマイナス57度。エリダヌスの川を南に下った終点に青白く輝く星である。日本からだと鹿児島あたりまで南下して、やっと地平線すれすれのところで観測が可能となる。ただし、南天の星座を探すときには重要な役割を果たす星である。地球からの距離は140光年。

## ハダル
### Hadar

ケンタウルス座のβ星ハダルは0.6等級。全天で11番目の明るさをもつ。青白く輝く星である。直径は太陽の15倍、明るさは5万5000倍程度と考えられている。地球からの距離は392光年。リゲル・ケンタウルスと比べればずいぶんと遠い。実際にはハダルの方が明るい星なのである。ケンタウルス座は赤緯マイナス47度に位置し、東京からだとその半分しかのぞめない。その全貌を観察するには沖縄あたりまで南下するしかないのだ。ケンタウルス座の二つの1等星リゲル・ケンタウルス、ハダル、ともに一般に馴染みが薄いのはこのためである。

## スピカ
### Spica

乙女座のスピカは1.0等級。全天で15番目の明るさをもつ純白の星である。日本でも古来より「真珠星」として親しまれてきた。スピカは五重星で、その中の大きな二つは太陽の11倍と7倍の大きさをもつ。表面温度もそれぞれ2万度、1万8000度と高い。その二つの星は4日周期で互いのまわりを回りあう近接連星なのだ。主星は高速で自転（秒速200km）している上に、互いに引力で影響しあっているため、かなり歪み扁平な球体になっている。赤色巨星になる日もそう遠くない。地球からの距離は250光年。

ベガ

ベガ
*Vega*

琴座のベガは0・0等級。全天で5番目の明るさをもつ白色星である。夏の星座の中ではもっとも明るい星だ。全天でたった一つの「第1次標準星」という重要な役割をもつ。すべての星の明るさは、ベガの明るさを基準に決められているのだ。ベガは地球の歳差運動（2万6000年周期の首ふり運動）によって、1万2000年後には北極星として真北の空に輝くことがわかっている。地球からの距離は25光年。

鷲座のアルタイルは0.8等級。全天で12番目に明るい白色の星(表面温度は8250度と高温)である。日本では琴座のベガとともに織姫、彦星として親しまれているが、西洋ではベガ(落ちる鷲)、アルタイル(飛ぶ鷲)として対をなしている。自転周期がきわめて早く、たった7時間(太陽は25・38日)で1回りしてしまう。秒速にすると200kmにもなるため、扁平な球体に見える(赤道方向が極方向よりも14%も膨らんでいるのだ)。直径は太陽の1.9倍。実際の明るさは太陽の約11倍。地球からの距離は17光年。

## アルタイル
### Altair

アルタイル

## アルデバラン
### Aldebaran

牡牛座のアルデバランは0.8等級。全天で13番目に明るい（鷲座のアルタイル、南十字座のアクルックスも0.8等級）。オレンジ色の巨星で、牡牛の目の位置で輝いている。直径は太陽の約50倍、質量は約25倍もある。星の外層が大きく広がって不安定なため、0.75等級から0.95等級まで不規則に変光する。希薄なガスが太陽系の3倍もの大きさまで広がり、さらにその外側には低温のガスと塵による殻構造（シェル）ができていることが判明している。地球からの距離は67光年。

アンタレス
Antares

蠍座のアンタレスは1・0等級。全天で16番目に明るい赤い星だ。宮澤賢治の「星めぐりの歌」でも「さそりの赤い目玉」と歌われている。直径は太陽の約700倍もある。オリオン座のベテルギウスと同じ赤色超巨星である。牡牛座のアルデバラン同様、きわめて不安定でガスと塵による殻構造に包まれている。さらにその外側には巨大なガスの雲が広がっている。やがては超新星爆発をおこす運命にあり、その影響は地球にまでおよぶと考えられている。地球からの距離は553光年。

## アクルックス
### Acrux

南十字座のアクルックスは0・8等級。全天で14番目に明るい（鷲座のアルタイル、牡牛座のアルデバランも0・8等級）。青白い光を放つ。二つの1等星と2等星、3等星で美しい十字を描く。南天の星空のシンボルともいえる星座のα星である。1等星の中ではもっとも天の南極の近くで輝く。地球からの距離は324光年。

## ベクルックス
### Becrux

南十字座のベクルックスは1・3等級。全天で19番目の明るさをもつ青白い巨星である。もう一つ1等星アクルックスとともに、美しい十字を南天の夜空に描く。一つの星座に二つの1等星をもつのは、南十字座のほかは、オリオン座とケンタウルス座しかない。南極星にあたる星をもたない南天におけある、最大のシンボルである。質量は太陽の14倍にもおよび、星の生涯の最終段階を迎えようとしている。地球からの距離は279光年。

ガクルックス

ベクルックス

アクルックス

## ガクルックス
*Gacrux*

南十字座のγ星は1.6等級。ガクルックスとよばれる明るい2等星だ。南十字座にはアクルックスとベクルックスという二つの1等星が存在する。この星座が夜空に美しい十字架を描き、南天のシンボルとなっているのは、明るい星がわかりやすいカタチに配置されているからに他ならない。十字架のもう一つの端には3等星。地球からの距離は89光年。

デネブ

## デネブ
*Deneb*

白鳥座のデネブは1.3等級。全天で20番目に明るい純白の巨星である。デネブはアラビア語で「めんどりの尾」の意。羽をひろげたカタチの星の並びは十字に見えることから、「北十字星」ともよばれる。直径は太陽の約200倍、質量は約20倍、表面温度は1万度を超える。ただ地球からの距離は1424光年と、とんでもなく遠い。実際の明るさは太陽の10万倍もあり、夜空に輝く星の中ではもっとも明るいのだ。銀河系有数の超巨星で、すでに水素は燃え尽き、ヘリウムを燃やして輝いている。200万年以内には超新星爆発をおこすとされている。

## レグルス
### Regulus

獅子座のレグルスは1・3等級。全天で21番目に明るい白色の星である。コペルニクスはこの星に「レグルス（小さな王）」の名をつけたが、ローマ時代には「獅子の心臓」とよばれていた。1等星の中では暗い星ということになるが、実際は直径が太陽の3・8倍、表面温度は1万3000度、太陽の330倍もの光を放っている。高速自転（秒速330km）をしていて、赤道方向に膨らんだ回転楕円体をしている。また8等星の伴星をともなう二重星であり、黄道（太陽の通り道）上に位置するロイヤルスターの一つでもある。地球からの距離は79光年。

## ポラリス
*Polaris*

子熊座のα星ポラリスは2.0等級。2等星の中ではもっとも有名な星であろう北極星のことである。日本でも「北の一つ星」「心の星」「子の星」「方角星」など様々な名で親しまれてきた。現在は天の北極から約1度ずれている。直径は太陽の46倍もあり、2200倍もの光を放っている。小さな伴星をともなっている。地球からの距離は433光年。

ポラリス

051
050

## フォーマルハウト
*Fomalhaut*

南の魚座のフォーマルハウトは1・2等級。全天で18番目に明るい白色の星である。直径は太陽の1・9倍、表面温度は9300度。黄道上に位置する四つの1等星の一つで「ロイヤルスター」とよばれる。残りの三つは獅子座のレグルス、蠍座のアンタレス、牡牛座のアルデバラン。1983年、この星のまわりに塵の円盤が存在していることが赤外線観測衛星IRASによって発見された。似たような塵の円盤は琴座のベガでも発見されている。このような円盤の存在は太陽系に近い惑星があることを示唆するものである。地球からの距離は25光年。

## 大犬座ε星（イプシロン）
*Epsilon Canis Majoris*

大犬座のε星は1・5等級。2等星の中ではもっとも明るい。ちなみに1・5等級から2・4等級までが2等星とされる。この星座のα星シリウスが全天でもっとも明るい星として有名なのに対して、わずかに0・1等級だけ1等星の明るさに届かないだけなのに名前さえつけられていない。話題になることもなかなかない。悲しい星なのだ。地球からの距離は405光年。

## ミラ
*Mira*

鯨座のο星は「ミラ(不思議という意味)」とよばれる2・0等級だが、人類がはじめて発見した変光星として、有名である。332日の周期で2等級から10等級まで明るさを変える。変光するのは収縮と膨張を繰り返しているため。大きく膨らんだときは太陽の700倍にも達するのだ。ちなみに鯨座ではτ星(3・5等級)も有名である。地球からの距離は12光年と近いため、宇宙人からの信号を受信しようとする試み「オズマ計画」の目標とされたのだ。

## オリオン座γ星
*Gamma Orionis*

オリオン座のγ星は1・6等級。ちなみにε星は1・7等級、ζ星は1・8等級。いずれも1等星に近い明るい2等星である。加えてα星(ベテルギウス、0・4等級)とβ星(リゲル、0・1等級)という二つの明るい1等星をもつのだ。オリオン座が全天でもっとも見つけやすい星座であることは無理からぬことである。γ星の地球からの距離は252光年、ε星は1977光年、ζ星は735光年。

## カストル
### Castor

双子座のα星（カストル）は1・6等級。肉眼では一つの星にしか見えないが、2・0等級（A）と2・9等級（B）からなる二重星である。実はこのA星もB星も二重星であることがわかっている。しかもこの四つの星の近くにはやはり二重星のC星が回っている。接近した3組の二重星が、複雑に影響しあっている六重連星なのだ。カストルの惑星に人が住んでいるとしたら、六つの太陽がぐるぐるまわりを回っていることになる。ずいぶんとにぎやかな空になることだろう。地球からの距離は51光年。

## ポルックス
### Pollux

双子座のβ星ポルックスは1・1等級。全天で17番目に明るいオレンジ色の星である。直径は太陽の8・3倍。実際の明るさは太陽の32倍にもなる。ギリシア神話では拳闘が得意で不死身の弟ポルックスが乗馬の名手である兄カストルの仇を討つ。その後、空へのぼって星となる。地球からの距離は34光年。カストルは1・6等級。地球からの距離は51光年。地球から見ると少し奥まったところに位置して、少し暗い。もしかしたら兄は仇を討ってくれた弟に遠慮しているのかもしれない。

ポルックス

カストル

055
054

ペルセウス

ぎょしゃ

オリオン

ふたご

こいぬ　　　W

いっかくじゅう

んばん

春

Spring

4/5 = 23:00
4/20 = 22:00
5/5 = 21:00
5/20 = 20:00

春の代表的な星座の一つである。とはいっても、1年中北の空に浮かんでいる。このため方角を知るための星座として重要である。北極星を見つけるための目印としてはあまりにも有名だ。ひしゃくのようなカタチの北斗七星は、この大熊の背中から尾の部分にあたる。七つの星は六つが2等星、一つだけが3等星で、肉眼でも観察可能な二重星（ひしゃくの柄の部分のはしから2番目、ミザールとアルコ）が含まれている。北斗七星に関する物語は世界中に数多く残されている。ロシア民話ではひしゃく、中国神話では生と死をつかさどる神様、アメリカ先住民の民話

## 大熊座
### Ursa Major

では熊と3人の狩人、日本民話では剣になぞらえられている。またカタチが馬車、人力車に似ていることから、「車」とよばれることも多かったようだ。バビロニアでは「荷車」、スカンディナビアでは「オーディンの車」、中国では「帝車」、イギリスでは「アーサー王の車」となる。ギリシア神話では、北斗七星だけでなく200ほどの星々とともに大熊にみたてられた。この熊、もともとは美しいニンフ、つまり森と泉の妖精カリストだった。なぜ、この美しい妖精カリストが大熊座になるのかについてはつぎの子熊座の項で。

ミザールと
アルコ

春の宵の北の空高くに、北斗七星のそばに北斗七星とよく似た小さなひしゃくを見つけることができる。北極星のある小熊座である。小熊座も1年を通して見ることができるため、方向を知るための重要な星座である。日本でも北極星のことを「北の一つ星」「心の星」「子の星」「方角星」などとよんできた。ただし、地球の自転軸はゆっくりと小さく円運動をしているため、真北をしめす星はいずれ別の星にとって代わられることとなる。ちなみに8000年後には白鳥座の1等星デネブ、1万2000年後には琴座の1等星ベガがその役割を果たすことになりそうだ。

## 小熊座
### Ursa Minor

さて、ギリシア神話である。森と泉の妖精カリストは月と狩りの女神アルテミスの侍女だったが、大神ゼウスの寵愛を受けその子を産み落とす。アルテミスは怒り狂い、カリストを熊の姿に変えてしまう。15年の歳月が流れ、カリストの子アルカスは腕のよい狩人となっていた。ある日、アルカスは森で熊となった母と出会う。立派になった息子を抱きしめようとカリストはアルカスに走り寄るが、その熊が母とはしらないアルカスは熊に弓を引こうとする。これを見ていたゼウスは、アルカス（小熊座）も熊の姿に変え、カリスト（大熊座）ともども天上に導き上げたのだ。

ポラリス

蟹座は黄道十二星座の第4座。十二星座の中ではもっとも暗い星座だが、黄道上にあったため500 0年もの昔のバビロニアでも知られていたという。春先の宵、双子座の1等星カストルとポルックス、獅子座の1等星レグルスを結んだ中間点あたりに、ぼんやりとした淡い光芒（プレセペ星団、プレセペはかいば桶という意味のラテン語）が見えるはずだ。これが蟹の甲羅の部分である。ギリシア神話に登場する蟹は、英雄ヘラクレスの化け蛇退治に登場する化け蟹と

## 蟹座
Cancer

されている。化け蛇（ヒドラ、海蛇座）退治にやってきたヘラクレスは化け蛇に加勢した化け蟹をあっさりと踏みつぶしてしまう。ヘラクレスは大神ゼウスとミュケナイの王女アルクメネとの間にできた子である。ゼウスの妻、女神ヘラは嫉妬深く、ヘラクレスを憎み、これを亡き者にしようと化け蛇退治を仕組んだのだ。ヘラは、ヘラクレスに敗れはしたものの、自分の策略のもと死んでいった化け蛇と化け蟹の死を悼み、2匹を天に召し上げ、星座にしたのである。

プレセペ星団

## 獅子座
*Leo*

獅子座は黄道十二星座の第5座。春、南の空で見られるカタチの整った美しい星座である。1等星であるレグルスを筆頭に4等星以上の星が21個も存在する。青白い星レグルスは「小さな王」という意味でコペルニクスによる命名である。ライオンの頭の部分は「？」を左右逆にしたような並び方が特徴的で「獅子の大鎌」とよばれ、親しまれている。日本でも「樋かけ星」とよんでいた地方もある。ライオンのしっぽのところにあるのは2等星のデネボラ（アラビア語で「獅子の尾」の意）。牛飼座の1等星アルクトゥルスと乙女座の1等星スピカを結んで「春の大三角」を描く。春の星座観察に欠かせない目印である。獅子座といえば「獅子座流星群」。毎年11月に観察できるものだが、およそ33年に1度、大出現する。1833年、アメリカでは「世界が火事だ」と人々が泣き叫んだほど（一晩で24万個の流星が見られたという）。ギリシア神話では、獅子はやはりヘラクレスの相手として登場する。ネメアの森の暴れ獅子退治は英雄ヘラクレスに与えられた「12の難行」の最初である。ヘラクレスは不死身の獅子を棍棒で気絶させたのち、自慢の怪力で絞め殺す。残された獅子の毛皮はその後ヘラクレスの象徴となった。

海蛇座は春から夏にかけて南の空に横たわる巨大な星座である。蟹座から獅子座、乙女座をへて天秤座まで続くのだ。頭部から尾の先まで100度（実に天球の円周の4分の1以上を占める）を超える幅がある。ここまで大きいと頭部が南中しても、尾の先は地平線の下に隠れてしまったままということになる。一番目立つのは海蛇の頭部になる、6個の星たちだ。大きな口を開け、まるで小犬座の1等星プロキオンを狙っているようにも見える。海蛇の心臓に当たる位置で赤く光っているのは2等星アルファルドである。きわめて活発な活動をしている星で、脈打つ

## 海蛇座
### Hydra

ように振動していることが判明している。心臓とよばれるにふさわしい星なのである。ギリシア神話では、この海蛇は九つの頭を持ち猛毒を吐くヒドラという化け蛇である。ヘラクレスに与えられた「12の難行」の2番目に登場する。ヒドラの首は打ち落としても打ち落としても、再びはえてくる。困り果てたヘラクレスは甥のイオラオスに知恵を借り、切り口を焼くことにした。最後の首は切り落とし巨大な岩の下に埋めたのである。海蛇座の首が一つしかないのはこのためだ。星座となった理由は蟹座の項の通りである。

アルファルド

## コップ座
Crater

コップ座は海蛇座、獅子座、乙女座の中間あたりに位置する小さな目立たない星座である。四つの星で構成される烏座の四辺形のすぐ横にあるといった方が見つけやすいかもしれない。コップといわれると水やビールを飲むためのガラスコップをイメージしてしまうが、このコップはギリシア風の把手つき、台座つきの立派な盃（運動競技の優勝者などが受け取る杯）のことである。古代ギリシアでは盃がきわめて日常的に使われていたため、この星座のコップについて数多くの持ち主が逸話として残されている。まずは、酒と収穫の神ディオニュソス（バッカス）が酒をつくる鉢としていたというもの。二つ目は、嘘つきのカラスに腹を立てた太陽神アポロンがおびき寄せるために使った盃とともにカラスを星空にさらしてしまったというもの。三つ目は、魔女メーディアが若返りの魔術をおこなうために使った釜であるというもの。ほかにも英雄ヘラクレスの盃だったという話も残されている。

春から初夏にかけて宵の南の空には、海蛇座がその長大な姿を横たえている。その背には六分儀座、コップ座、烏座の三つの星座がのっかったまま、東から西へとゆっくりと動いていく。六分儀座とコップ座については、そうそう簡単に見つけ出すことはできないかもしれないが、烏座の四つの3等星がつくる少し歪な四辺形は、意外と目につく。この四辺形は日本人にとっても、わかりやすい存在だったようで、各地に「四つ星」「帆かけ星」「はかま星」「皮はり星」など多くのよび名が残されている。ギリシア神話では、カラスは太陽神アポロンの使者として登場する。

## 烏座
*Corvus*

このカラス、銀の翼を持ち、人の言葉をしゃべった。賢いがおしゃべりで少々嘘つきなところが玉に瑕である。そのころ、アポロンはテッサリア王の娘コロニスと恋仲であった。忙しすぎてコロニスに会えないアポロンはカラスを伝達役として連絡を取り合っていた。ある日、カラスは道草を食って遅くなった言い訳にコロニスの浮気話をアポロンに告げる。怒り狂ったアポロンはコロニスを死に至らしめるのだが、後に浮気の事実はなく、カラスの嘘であったことを知る。カラスは黒い翼に変えられ、人の言葉も取り上げられ、空にさらされることになった。

071
/070

## 牛飼座
Boötes

夏至を迎える頃、牛飼座はほぼ天頂の位置にやってくる。細長い五角形の部分が胴体で、2匹の猟犬を引く手を大きく掲げている。ちょうど股間の部分にあるオレンジ色に輝いている星が、1等星アルクトゥルスである。日本でも麦秋（6月の麦刈りの始まる頃）に頭上に輝くことから、麦星の名で親しまれてきた。さて、この棍棒を持ち、猟犬を連れた牛飼の大男、正体ははっきりとしない。熊になった母とは知らず熊を追い立てるアルカス（子熊座）という説もあるが、ここでは天を担ぐ巨人アトラスとして話を進めよう。西の果てヘスペリデスの園にあるリンゴを

入手しなければならなくなった勇者ヘラクレスは、リンゴの木を守るヘスペリデスの三姉妹の父、アトラスに相談を持ちかける。アトラスはリンゴと引き換えに天を担ぐ仕事をヘラクレスに代わってもらう。ゼウスに永遠に天を担ぐよう命じられていたアトラスはその仕事に飽き飽きしていたのだ。首尾よくリンゴを手に入れて帰ってきたアトラスに、ヘラクレスはこう持ちかける。「肩が痛くてたまらない。どうすればうまく担げるのか、見本を見せてくれないか」。ヘラクレスはまんまとリンゴを手に入れその場を立ち去ってしまう。

アルクトゥルス

## 猟犬座
### Canes Venatici

春の夜空の見ものといえば、なんといっても北の空で大きな存在感をしめす北斗七星である。その北斗七星を含む大熊座から牛飼が引き連れる猟犬として独立させたのは、ヘベリウス（ポーランド領のグダニスク生まれ、17世紀の天文学者）である。結果として猟犬座は北斗七星と牛飼座の1等星アルクトゥルスの間に位置することとなった。この猟犬たち、北の犬はアステリオ、南の犬はカーラとよばれる。天空で、牛飼とともに大熊を追い立てるようにも見える。猟犬座のα星はコル・カロリ（「チャールズ王の心臓」の意）。3等星ながら、周りに明るい星がないため印象的な存在である。この星、2・9等級と5・6等級の星が並ぶ二重星だ。牛飼座の1等星アルクトゥルス、乙女座の1等星スピカ、獅子座の2等星デネボラがつくられる三角形を「春の大三角」というのに対して、コル・カロリとでつくられる四角形を「春のダイヤモンド」という。また、北斗七星からアルクトゥルス、スピカとつながる曲線を「春の大曲線」とよぶ。星座観察のための大事な手がかりである。

アステリオ

カーラ

コル・カロリ

猟犬座の3等星コル・カロリと獅子座の2等星デネボラの中間あたりに春霞のように微光星がひとかたまりとなっている。この星粒の群れは散開星団とよばれるもので、ここではおよそ40個ばかりが集まっている。髪の毛座はこの散開星団そのものが星座という珍しい存在である。古くから知られていた星座（紀元前3世紀には「善き行いのベレニケの髪」とよばれていた）だったが、プトレマイオスの48星座には含まれていない。この星座を復活させたのは近代における星座の父ともよばれるデンマークの天文学者ブラーエ（1546年生まれ）である。さて、髪の毛

## 髪の毛座
Coma Berenices

座の名の由来である。紀元前3世紀、エジプトを治めていたのは善行王とよばれるエウエルゲテスであった。彼には美しい髪をもつベレニケという妃がいた。ある時、シリアとの戦いで劣勢に立たされたエウエルゲテスは自ら軍を率いて出陣することになる。不安になったベレニケは、アフロディテの神殿に詣で夫の勝利と引き換えに自慢の髪を捧げることを誓う。夫は見事勝利をおさめて帰国する。祭壇に祭られていたはずの髪はいつの間にか消えていた。大神ゼウスが、その妃の髪の美しさを愛で、天に召し上げ星座としたからだ。

乙女座は黄道十二星座の第6座。晩春から初夏にかけて、南の空で観察することができる。全天で2番目に大きな星座である。北斗七星からつながる春の大曲線をたどっていくと、白く清楚な輝きを放つ1等星スピカと出会えるはずだ。スピカのある位置はちょうど女神が手にもつ麦の穂先にあたる。日本でも「真珠星」とよばれた美しい星である。ただし、スピカ以外には目立った星はなく、女神の姿を星空から想像することは容易ではない。この女神については諸説が入り乱れている。その一つは正義の女神アストライアというものだが、この説については天秤座の

## 乙女座
*Virgo*

項に譲ることとする。ここではもう一つの説、農業の女神デメテルの娘ペルセポネについて語ろう。ペルセポネを見初めた冥界の王ハデスは、野で遊ぶ彼女を冥界に連れ去ってしまう。デメテルは絶望のあまり洞窟に閉じこもってしまい、農業の女神が姿を消した地上は1年中作物のとれない冬の季節が続くことになった。これに困ったゼウスは仲介に入り1年のうち8か月はデメテルのもとで、4か月はハデスのもとで暮らすようペルセポネに命じたのだ。1年のうち4か月だけ冬が訪れるのは、このためであるという。

スピカ

ケンタウルス座は春から初夏にかけて、南の地平線上に姿をあらわす。乙女座のスピカからずっと南に視線を落としたあたりだ。東京付近からだと、その姿の半分しかのぞむことができないが、沖縄以南ではほぼ全体像を見ることができる。ケンタウルス座には、1等星が2個（リゲル・ケンタウルスとハダル）存在する。同様の星座はほかに、オリオン座と南十字座しかない。貴重な星座の一つである。ギリシア神話ではケンタウルス族（半人半馬）は粗暴者として登場することが多いのだが、射手座のケイロンとケンタウルス座のフォローだけは、それぞれ賢者、

## ケンタウルス座
### Centaurus

誠実者として描かれている。フォローは酒と収穫の神ディオニュソスの養父シレノスの子である。あるとき、ヘラクレスとともにディオニュソスからの贈り物である美酒を楽しんでいた。このとき、ふたりは酒の匂いをかぎつけたケンタウルス族の襲撃を受ける。これに怒ったヘラクレスは、ヒドラ（海蛇座）の血から採った猛毒を塗った矢で応戦する。瞬く間に彼らを蹴散らしてしまうのだが、たまたま落ちていた矢を拾ったフォローがこの毒に触れ、死んでしまう。ゼウスがこれを哀れに思い、天に召して星座にしたのだという。

リゲル・
ケンタウルス

ハダル

## 山猫座
*Lynx*

春に天頂からやや北寄りの空、大熊座の隣に見えるのが山猫座である。一番明るい星でも3等星で、ほかは暗い星ばかり。印象の薄い目立たない地味な星座である。この星座を定めたポーランドの天文学者ヘベリウスでさえ、「この星座に山猫の姿を見つけ出すには、山猫のような鋭い眼をもっていなければならない」などと言い訳がましいことを書いているくらいだ。命名当初の原名は「山猫もしくは虎座」だが、ヘベリウスの描いた星座の絵姿はけっして虎には見えない。

プラエキプア

## 小獅子座
### Leo Minor

初春の頃、東の空、獅子座と大熊座の間に見られる小さな星座である。山猫座と同様にポーランドの天文学者ヘベリウスが17世紀になって新設したものだ。星座を構成する星はすべて4等星以下である。暗く目立たない星座なので、夜空に小さな獅子の姿を見つけ出すのは容易なことではない。ヘベリウスはこの星座で一番明るい4等星にプラエキプア（ラテン語で「主要なもの」の意）と命名したが、これには少々無理があったようで、定着はしなかった。

## 六分儀座
### Sextans

六分儀座は獅子座の1等星レグルスと海蛇座の2等星アルファルドの間に位置する。この星座もポーランドの天文学者ヘベリウスが新設した10の星座（現存しているのは7個）の一つで、やはりほかのものと同様に目立たない小さな星座である（すべての星が4等星以下）。六分儀は天体観測、航海、測量などに使う道具。ヘベリウスは自宅が焼けた際、愛用の六分儀を焼失してしまい、二度と災難にあわぬよう、勇猛な獅子と海蛇の間に置いて守ってもらうことにしたという。

## ポンプ座
### Antlia

ポンプ座は春、南の地平線近く海蛇座の南側に見られる星座だ。このポンプとは水をくみ上げるための道具ではなく、科学実験に使用された真空ポンプのことである。18世紀半ば、フランス生まれの天文学者ラカイユが新設した14星座の一つだ。ラカイユは当時自ら南半球にまで足を運んで天体観測をおこなった数少ない天文学者の一人である。ポンプ座には4等星以下の淡い光を発する星しかなく、見つけることも、ポンプの姿をイメージすることも容易ではない。

# 狼座
## Lupus

狼座は春の星座というよりも初夏の星座かもしれない。また、日本からは地平線の近くにしか見られないので、やや馴染みの薄い星座である。東京からだと、もっとも見やすい7月頃でも3分の1は地平線の下に隠れてしまう。ルネッサンス期からケンタウルスの槍に突き刺された狼に見立てられていた。もともとはケンタウルス座の一部だったのである。人肉を宴席に出して大神ゼウスの怒りをかったアルカディオンの王リュカオンの一族が狼に姿を変えられたものだ。

りょうけん

かみのけ

おとめ
W

うしかい

てんびん
うみへび

うみかみ

夏

*Summer*

7/5 = 23:00
7/20 = 22:00
8/5 = 21:00
8/20 = 20:00

## 蠍座
### Scorpius

蠍座は黄道十二星座の第8座。夏、南の中天で巨大なS字を描くその姿はもっとも見つけやすい星座の一つである。サソリの心臓で真っ赤に輝く1等星はアンタレス。古来より人々から注目を集めてきたきわめて印象的な星である。中国では「大火」、日本では「赤星」「酒酔い星」などとよばれてきた。アンタレスの名も、アンチ・アレス（火星に対抗するもの）に由来する。蠍座のS字は、釣り針にそっくりなので、瀬戸内海では「魚釣り星」「鯛釣り星」などの名も残っている。狩人オリオンは海神ポセイドンの子。腕っぷしの強さが自慢で、日頃から「俺様にかなうものなどこの世に存在しない」と大言壮語するようになっていた。大王ゼウスの妻ヘラは、この乱暴者の行状を苦々しく思い、猛毒をもつ一匹のサソリを遣わし、草むらで待ち伏せさせる。さすがのオリオンもサソリの猛毒にはかなわず、あっけなく息絶えてしまった。サソリはその功績を称えられ、天にのぼって星座となったのである。オリオンも星座になったのだが、今でもサソリを恐れ、蠍座が夜空にのぼる時分になるとこそこそと地平線の下に隠れてしまうのだ。

アンタレス

射手座は黄道十二星座の第9座。天の川の一番明るく幅広いところに位置している。夏から初秋にかけて南の空で観察することができる。中心は南斗六星と名づけられた6個の星たちで、ミルキィウェイ（天の川）のミルクをすくうスプーンという別称もある。射手座はケンタウルス族の賢者ケイロンが星座になったものだ。ケイロンはゼウスの父クロノスと月の神アルテミスから音楽、医学、予言、狩りなどの知識・技術を学び、ペリオンの山でギリシアの若き英雄たちに教育をほどこしていた。ヘラク

## 射手座
*Sagittarius*

レス（ヘルクレス座）やカストル、ポルックス（双子座）、イアソンに は武術を、アスクレピオス（蛇遣い座）には医術を伝授したのである。ある日、ヘラクレスに追われたケンタウルス族がケイロンの洞窟に逃げ込んでくる。ヘラクレスは中にケイロンがいるとは知らず、ヒドラの毒を塗った矢を放つ。ケイロンはクロノスの子であったため、不死身の体をもっていたのだが、この猛毒には苦しめられた。死ぬに死ねないからだ。とうとう傷の痛みに耐えかねたケイロンは不死身の力をプロメテウスに譲り死の床についたのである。

天秤座は黄道十二星座の第7座。初夏の宵、南の空を見上げると、乙女座のスピカと蠍座のアンタレスのほぼ中間あたりに、三つの3等星が平仮名の「く」を裏返しにしたカタチで並んでいる。かつては蠍座の一部で、爪の部分だったようで、個々の星にも「南の爪」「北の爪」などの名が残されている。秋分点がこの星座の中に存在していたこともあり（現在の秋分点は乙女座に移っている）、昼と夜の長さを等しく分けるというイメージが天秤座の名の由来の一つである。ギリシア神話においてはこの天秤は正義の女神アストライアのものである。黄金の時代、人々は

## 天秤座
*Libra*

なに不自由なくしあわせに暮らしていた。これが銀の時代になると冬が訪れるようになり、貧富の差が生まれ始め、人々は争いを始めるようになる。神々は天上界に去ったがアストライアは地上界に残り正義を説き続けた。このとき、争いごとの正邪をはかったのが彼女の天秤である。さらに銅の時代、鉄の時代になると、人々はますます野蛮になり、人殺しや戦争まで始めてしまう。ここに至ってアストライアは地上界を見限り天上界に昇り、星座（乙女座）になるのである。もちろん正邪をはかる天秤も天に昇り星座となった。

## 冠座
Corona Borealis

7月の中頃、ほぼ天頂、牛飼座のそばで観察できる小さな星座である。七つの星々が美しい半円形を描くので、見つけやすい星座の一つかもしれない。日本では「鬼の釜」「長者の釜」「地獄の竈」「太鼓星」「首飾り星」などの名でよばれていた。オーストラリアでは「ブーメラン」、ペルシアでは「乞食の皿（縁のかけた皿に見立てて）」などのよび名がある。さて、ギリシア神話である。アテネの王子テセウスはクレタ島の王女アドリアネの糸車の助けを借り、迷宮の魔物ミノタウルス退治に成功する。アドリアネを妻に迎え、アテネに向かっていたテセウスは、途中、酒と収穫の神ディオニュソスの住むナクソス島に寄港する。ここでテセウスは夢を見る。夢にアテナ女神があらわれ「アドリアネを妻とすれば災いが訪れる」と告げられたのだ。テセウスは翌朝、アドリアネをナクソス島に置き去りにして、あわてて船を出す。ディオニュソスは、身を投げようとしていたアドリアネを慰め、妻として迎える。このとき、愛の証として花嫁に贈られたのが七つの宝石をあしらった冠である。この宝冠が天に昇り星座となった。この星座のα星の名はゲンマ、「宝石」を意味する。

ゲンマ

ヘルクルス座はもちろん英雄ヘラクレスの姿を星空にうつしたものである〈ヘルクルスはヘラクレスのラテン語読み〉。真夏の盛り、天頂付近で観察することができる。全天で5番目に大きな星座だが、構成する星はいずれも3等星以下の暗めな星ばかりで、ギリシア神話で八面六臂の大活躍をする人気者の星座としてはいささか寂しい。
ヘラクレスは大神ゼウスとアルゴスの王女アルクメネの間にできた子である。ゼウスの妻ヘラは、この子の誕生を呪い、様々な苦難をヘラクレスにもたらす。赤ん坊の頃送り込まれた毒蛇は素手で握りつぶして難を逃れるのだが、ヘラが遣

## ヘルクルス座
### Hercules

わした狂気の女神の力によって成人ののち、わけもなく妻子を殺し火の中に投げ込むという大きな罪を犯してしまう。その罪をつぐなうため、いとこのアルゴス王エウリステウスの命に従うことになる。
このとき与えられたのが「獅子退治〈獅子座〉」「大猪退治〈海蛇座〉」「化け蛇退治」など「12の難行」である。ヘラクレスはケンタウルス族のネッソスがいまわの際についた嘘が原因で死んでしまう。ネッソスは自身の血が「浮気防止の秘薬」であるとヘラクレスの妻デイアネイラに告げるのだが、この血、実際はヒドラの猛毒だったのである。

099
098

## 琴座
*Lyra*

夏の宵、天の川のほとり、ほぼ天頂の位置に浮かぶ。蠍座とともに夏を代表する星座の一つである。この星座の目印ともいえる1等星ベガは、夏の夜空でもっとも明るく輝く。ヨーロッパでは「夜空のアーク灯」「夏の夜の女王星」として広く親しまれてきた。日本でも織姫星と七夕伝説を知らぬ人はいないだろう。ギリシア神話では、音楽の神アポロンから竪琴の名手オルフェスに贈られたものとされている。ある日、オルフェスの妻エウリディケは毒蛇にかまれ死んでしまう。妻を深く愛していたオルフェスは妻を取り戻すべく冥界に足を踏み入れる。竪琴を弾き歌うことで渡し守のカロンや番犬ケルベロス、亡霊たちをやり過ごしたオルフェスはとうとう冥界の王ハデスの前に行きつく。ハデスとその妻ペルセポネもその歌声の美しさに心動かされ、妻を連れ帰ることを許した。ただし「地上に戻るまではけっして振り返らない」という条件つきで。出口が見えてきたあたり、暗闇の中、不安は最高域に達する。そこでオルフェスはハデスとの約束を破り思わず振り返ってしまうのだ。彼の妻が二度と戻らない運命となってしまったことは、いうまでもない。

ベガ

夏の宵、頭上に横たわる天の川の東岸、琴座と向き合う位置に浮かぶ。ヨーロッパでは鷲座が「飛ぶ鷲」なのに対して、琴座は「落ちる鷲」とよばれ対をなしていたようだ。この星座の目印が1等星アルタイルである。日本では彦星（中国名は牽牛）。牽牛と織姫は仲睦まじくなりすぎて、仕事を忘れ、天帝の怒りをかう。結果1年に1度、7月7日の夜だけしか逢瀬を許されないことになってしまった。七夕伝説である。太陽暦の7月7日は梅雨の真っただ中だし、織姫も牽牛も空の低い位置にある。どうせ七夕を楽しむなら、旧暦で楽しみたいところだ。織姫も牽牛も

## 鷲座
*Aquila*

宵の空の頭上高く輝いているはずである。ギリシア神話では、数多くの物語に鷲が登場する。空を自由に飛び回ることのできる鳥は天上を住処とする神々と結びつけやすかったのだろう。例えば、こんな話が伝えられている。トロイアの美少年ガニメデスはその美しさが天上界にまで届いたほどであったという。大神ゼウスは、この少年をオリンポスの宮殿で開かれる神々の宴席にはべらせるため、鷲に姿を変え地上にさらいに出かける。ガニメデスには永遠の若さと美しさが与えられた。このときの鷲が星座になったというのだ。

アルタイル

夏から秋にかけて天頂付近で観察できる。白鳥の尾の部分で輝く1等星デネブ（「尾」の意）から描かれる十文字は見事というほかない。南半球の南十字星に対して、北十字星（「キリストの十字架」「ゴルゴダの十字架」などのよび名もある）とよばれるのもうなずける。

この十字架は12月の宵の頃になると、北西の空にまっすぐに立つ。

ちなみに宮沢賢治の「銀河鉄道の夜」は白鳥座を始発駅に、はるか南十字星まで旅する物語である。

ギリシア神話にはいくつかの説があるが、大神ゼウスがスパルタ王妃レダを口説くために化けた白鳥だ、というのが一般的である。レダを見初めたゼウスは愛と美の女神アフロディテ（ヴィーナス）に助けを求める。レダが夫を深く愛しており、当たり前のやり方ではとても口説き落とせないと考えたのだ。鷲に化けたアフロディテに追われた白鳥（ゼウス）は、レダのもとに逃げ込む。白鳥を哀れに思ったレダはその胸にそっと抱き寄せる。白鳥が飛び去るとレダは身籠っており、大きな二つの卵を産み落とす。一方の卵からはカストルとポルックス（双子座）、もう一方の卵からはトロイア戦争の原因となった美女ヘレンとクリュタイメストラが生まれるのだ。

## 白鳥座
Cygnus

デネブ

夏の宵を彩るのはまず天の川の光芒である。そして、琴座のベガ、鷲座のアルタイル、白鳥座のデブのつくる夏の大三角も見事だ。

しかし、天の川の西に目をやるとやや寂しい夜空が広がっているという印象を持たれるかもしれない。そこに巨大な蛇遣座が横たわっている。蛇遣座は黄道13番目の星座として近年注目を集めている。将棋の駒のような五角形をしている部分が蛇遣いの頭から胴のあたりだ。頭の部分で輝くのが2等星のラサルハグェで、ヘルクルス座の頭で輝くラス・アルゲティと向き合っている。さてギリシア神話である。蛇は脱皮を繰り返すので再

## 蛇遣座
Ophiuchus

生の象徴、医術の象徴であった。この蛇遣いは医者アスクレピオスの姿なのである。ケンタウルス族の賢者ケイロンに育てられ、医術を学んだ彼はギリシア神話第一の名医となる。ところが、あまりにも卓越した医術で死んだ人まで生き返らせるところまでいってしまったのだ。これに困った冥途の神プルトーンは大神ゼウスに「このままでは世の秩序は乱れ、地上は人であふれかえります」と訴えた。ゼウスは雷電の矢を放ち、アスクレピオスに死を与える。彼の死を惜しんだゼウスは、彼を天に召し星座としたのである。

ラサルハグェ

## 竜座
*Draco*

北極星の近く、北天の空に1年中浮かんでいて、地平線の下に隠れることはない。S字型にうねる巨大な星座である。竜の頭の部分は四つの星で構成されている。この星座のα星ツバーン（3等星）は、エジプトにピラミッドがつくられていた頃にはもっとも天の北極に近かった。当時は北極星の役割を果たしていたのだ。さて、この竜、ギリシア神話では、西の果てヘスペリデスの園にある金のリンゴを守っていた（牛飼座）。100の頭をもっていたとされる。ヘラクレスによって殺されてしまうが、ゼウスの妻ヘラに長年の功績が認められ、天に召され星座となった。

## 小狐座
*Vulpecula*

小狐座は白鳥座のすぐ南、矢座のすぐ北に位置する横長の星座である。いくつかの星がゆるい波形を描いており、身を潜める狐の姿を想像できなくもない。ただ、もっとも明るい星でも4・5等級で、基本的にはきわめて目立たない星座である。この星座を新設したヘベリウスは当初「鵞鳥をくわえた小狐座」などとよんでいたが、いつのまにか鵞鳥の方は名前から消えてしまったのだ。地味な星座ではあるが、「アレイ状星雲」とよばれる惑星状星雲M27が存在することで知られている。

ツバーン

アレイ状星雲（M27）

109
108

## 矢座
### Sagitta

矢座は夏の夜、東の空、天の川の中ほどに見える。全天の中でも3番目に小さい。ただ、4等星と5等星ながら、四つの星がはっきりと一文字を描いていて、わかりやすい星座である。古くから、ギリシア、フェニキア、アラビアなど、どの地域においても「矢」としてとらえられていたようだ。ギリシア神話では愛の神エロス（キューピッド）が携えていたものとされている。エロスは軍神アレスと愛と美の女神アフロディテの子である。エロスの黄金の矢で射られると深い恋に落ち、鉛の矢で射られるとどんな恋も冷めてしまうのだ。

## 蛇座
*Serpens*

蛇座は夏の夜、南の空に蛇遣座と重なって存在する。もともとは一つの星座だったのだが、48星座を定めるとき、プトレマイオスが蛇座を蛇遣座から独立させたのだ。蛇の胴体の部分は蛇遣いの腰の部分を共有している。蛇遣座の東に蛇の頭、西に蛇の尾があることになる。蛇座の見ものは、頭部にある球状星団M5と尾の部分にある散光星雲M16。球状星団は無数の星が集まってマリモのような球体に見えるもの。散光星団は明るく光って見える星雲のこと。M16は幻想的な3本の暗黒星雲（ガスや塵が光をさえぎってできる）をもつ。

# 海豚座(いるか)
*Delphinus*

天の川の東岸、鷲座の1等星アルタイルのそばにある小さな星座である。菱形に尾のついたカタチだ。3等星以上の星はないのだが、菱形の並びが印象的で、比較的見つけやすい。イルカは昔から神聖な動物とされており、海神ポセイドンの使いと信じられていたようだ。ギリシア神話によれば、音楽祭で優勝を勝ちとったアリオンはその帰路、優勝賞金狙いの海賊たちに襲われ海に投げ出される。彼を救ったイルカが天に召され星座になったという。ポセイドンとその妻アンフィトリテの仲をとりもった功績で星座に、という話も残されている。

## 楯座
Scutum

天の川の中でも、無数の星が集まりひときわ美しく光る雲のように見えるところがある。もっとも大きな光の雲が存在する射手座のあるあたりを「ビッグ・スタークラウド」とよぶのに対して、その北側に広がる光の雲を「スモール・スタークラウド」とよぶ。この「スモール・スタークラウド」のあたりが、楯座のある位置だ。ポーランドの天文学者ヘベリウスが新しく定めた星座の一つで、当初は「ソビエスキーの楯座」と名づけられた。ソビエスキーはポーランド王で、1683年ウィーンに攻めてきたトルコ軍を見事撃退した英雄だったからである。

アルフェッカ

# 南の冠座
## Corona Australis

射手座の南斗六星のさらに南に、小さな星々が半円形を描いている。南の冠座である。プトレマイオスが定めた48星座の一つで、歴史は古いが、神話は残されていない。射手座のそばにあることから「ケンタウルスの冠」「射手の冠」などのよび名もある。学名のコロナは太陽大気の最外層で皆既日食のときなどの冠状の光として見えるものが有名だが、もともと冠の意味をもつ。冠座と同様にこちらにもアルフェッカ（欠けた皿）の名をもつ星が存在する。

## 定規座
*Norma*

定規座は蠍座、狼座の南に位置する。日本本島からは星座の全体を観測することはできないため、南天の星座に分類されることもある。小さな旗のようなカタチをしていて、愛らしい。フランスの天文学者ラカイユによって新設された星座の一つである。星座全体を見るためには沖縄あたりまで足をのばさなければならないが、明るい星はなく、見つけるのは容易ではない。定規座の見ものはいくつかの星雲なのだが、残念ながら大望遠鏡がなければ観察は難しい。

## 祭壇座
Ara

祭壇座は蠍座のすぐ南、狼座の東に位置する小さな星座である。古代ギリシアの時代にはすでにその存在が知られており、プトレマイオスの定めた48星座の一つだ。日本からだと南の空の地平線に近いところでしか観察することはできない。歪んだ菱形と台形が組み合わさったようなカタチをしている。星図では供物を燃やす絵が描かれており、生贄を捧げるための祭壇のようである。神話ではバベルの塔の頂上に建つ神殿の祭壇であるとか、クロノス神が息子ゼウスに王位を奪われると予言された祭壇であるとか、いくつかの説が残されている。

## 望遠鏡座
*Telescopium*

望遠鏡座は射手座の南に位置する。星座全体を観察するためには石垣島、宮古島以南まで南下しなければならない。この星座もフランスの天文学者ラカイユは18世紀の中頃、南アフリカのケープタウンで3年にわたり、南半球の星々を観測。約1万個の星の記録を残した。17世紀に発明された望遠鏡が天文学の発展に大きく貢献したことはいうまでもない。ガリレオは望遠鏡を使って木星の衛星の存在を知り、天の川が星の集まりであることを発見したのだ。ラカイユは感謝の気持ちをもって星座に名をつけたことだろう。

ペルセウス

と

はくちょう

こぎつね

W

るか

わし

ま

ぎ

びきょう

秋

Autumn

10/5＝23:00
10/20＝22:00
11/5＝21:00
11/20＝20:00

## カシオペア座
Cassiopeia

秋の宵、北の空に五つの星がW字のカタチで並んでいる。W字というよりは、やや足が開き気味のM字というべきかもしれない。1年中、北の空で観察できる星座で北斗七星と同様に北極星を見つける目印となる。日本ではそのW字、M字の姿から「錨星」「山形星」などの名をもつ。古代エチオピアの王妃カシオペアは自身の美貌もさることながら、娘のアンドロメダ姫の器量を誇り、日頃から自慢の種にしていた。あるとき、「アンドロメダの美しさには、海神ネーレウスの娘たちでもかなうまい」といいふらしてしまう。これに怒った海神ポセイドンは大洪水と大津波を巻きおこす。「この神の怒りを鎮めるにはアンドロメダを生贄とせよ」の神託を受ける。アンドロメダは海岸の岩に鎖でつながれ、怪獣ティアマト（化けクジラ）に襲われるのを待つばかりとなった。そこへ勇者ペルセウスが天馬ペガススの乗ってあらわれ、メドゥサの首をティアマトに突きつけ、石に変えてしまう。石の塊となったティアマトは海中深く沈んでいくのである。一方、カシオペア王妃は高言の報いを受け、椅子に縛りつけられたまま、北の空をぐるぐる回る運命となったのだ。

121
120

アンドロメダの頭の部分に位置する星はペガスス座の大四辺形をつくる北東の星と同じものである。長い間、その星(アルフェラッツ、「馬のへそ」の意)は両方の星座に属していたが、1928年に星座境界線が定められ現在はアンドロメダ座の星となっている。化けクジラ座のティアマトから救い出されたアンドロメダ姫は、ケフェウス王とカシオペア王妃の許しを得、勇者ペルセウスの花嫁となる。この結婚にアンドロメダの婚約者であったフィネウスが異議をとなえ、祝いの席に乱入してくる。ペルセウスはまたもやメドゥサの首をつかって、これを撃退してしまう。

## アンドロメダ座
### Andromeda

さて、アンドロメダ大銀河M31(楕円形で銀河系に似ている)は天文ファンでなくとも、その存在を知る、秋の夜空を代表する天体の一つである。4・8等級と明るいため、望遠鏡が発明される前から、知られていたものだ。この天体、銀河系内のものではない。230万光年先にある銀河系外のものである。それでも、もっとも地球に近い銀河で、直径は22万光年(銀河系の約2倍)、約4000億個の星が含まれている。M31と銀河系は時速50万kmのスピードで接近しており、約30億年後には衝突すると考えられている。

アルフェラッツ

M31

秋の天の川、カシオペア座と馭者座の1等星カペラとの間、なんとなく「人」という字に見えるのがペルセウス座である。ただし、足は3本。1本は北にはねるカーブ、1本は足下にのびるカーブ、1本は変光星アルゴルにつながるカーブとなる。退治した女怪メドゥサの首をわしづかみにし、長剣をふりかざすペルセウスの姿である。

ペルセウスは大神ゼウスとアルゴスの王女ダナエの子として生まれた。「ダナエの子に命を奪われる」と神託を受けていたアルゴス王は娘と孫を海に流す。流された二人がたどり着いたセリーポス島の王はダナエに懸想し、邪魔な息子を

## ペルセウス座
Perseus

ゴルゴンの三姉妹の一人女怪メドゥサ退治へと追いやる。ペルセウスはアテナ女神からは鏡のように磨きあげた楯を、伝令神からは空を飛べる靴と姿を隠すことのできる兜を、流水の精女からは首をいれておく革袋を与えられる。メドゥサの寝所に忍び込んだペルセウスは鏡のような楯をつかい、目を合わせることなく、彼女の首を斬りおとすことに成功した。妻アンドロメダを連れてセリーポス島に帰ってきてみると、島の王は横暴をきわめていたため、メドゥサの首をきりとりまきをすべて石にして、島の平和を回復する。

アルゴル

## 鯨座
### Cetus

鯨座は晩秋から初冬にかけて、南の空に巨大な姿を見せる。秋の星座の中ではもっとも大きく、全天で4番目に大きな星座である。秋の大四辺形の東の辺を南に伸ばすと、鯨座の2等星デネブカイトス(「クジラのしっぽ」の意)にたどりつく。クジラの首のところに位置するミラ(「不思議な」の意)は、人類がはじめて発見した変光星である。およそ332日の周期で2等星から10等星まで明るさを変える。あるときは肉眼ではっきりと確認できるのに、あるときはまったく見えなくなってしまうという、まさに不思議な星である。ミラは年老いて太陽の500倍以上に膨れあがった赤色巨大星で、白色矮星の伴星をもつことでも知られている。安定を失ったミラは、風船のように膨らんだり縮んだりしながら、最期のときを待っているのだ。ギリシア神話では、海神ポセイドンも手を焼く化けクジラ、怪物ティアマトとして登場する。古代エチオピアを襲い、アンドロメダ姫を飲み込もうとしたところを勇者ペルセウスに退治されてしまう。クジラとはいっても、その奇怪な姿はセイウチかアザラシの化け物のように見える。

ミラ

デネブカイトス

## 山羊座
*Capricornus*

山羊座は黄道十二星座の第10座。秋の宵、射手座の東、南の空低くに逆三角形の姿を観察することができる。あまり明るい星はなく、どちらかといえば寂しい雰囲気の星座だが、古くから知られていた重要な星座の一つである。冬至点が山羊座にあった頃（現在冬至点は射手座に移っている）、南まで下がりきった太陽が再び北に戻っていくところを、岩山をのぼるヤギになぞらえたらしい。星図に描かれているヤギは普通のヤギではなく、下半身が魚という奇妙な姿をしている。もともとは森と羊と羊飼いの神パン（狂気をつかさどる神でもあったので、「パニック」の語源になった）であったとされる。パンはいつも葦笛を吹いて歌い踊り暮らしている陽気な神。あるとき、ナイル川の岸辺で、ほかの神々と宴会を開いて楽しんでいたところへ、大神ゼウスでさえもてあましていたという怪物テュフォン（こちらは「台風」の語源）があらわれる。神々はちりぢりに逃げ出した。パンもその姿を魚に変え、川に飛び込んだのだが、あわてていたため、上半身はヤギのままだったのだ。パンの川を泳ぐ姿があまりにおかしかったので、ゼウスはその姿を天に残し、星座にしたという。

129 / 128

水瓶座は黄道十二星座の第11座。秋、南の中天にのぼる。ペガスス座の南、山羊座の東に位置する大きな星座だが、明るい星はなく、美少年ガニメデスが水瓶をもつ姿を思い描くことは難しい。美少年の足もとで輝く秋の夜空唯一の1等星、南の魚座フォーマルハウトを目印にするしかないだろう。ちなみに水瓶からはとめどもなく水があふれ出ており、南の魚座の口に流れこんでいる。ガニメデスについてのギリシア神話は鷲座で紹介したとおりである。ただ、この星座ギリシア時代以前から水にまつわる名をもっていたようである。

## 水瓶座
### Aquarius

学名のアクアリウスは「水をもつ男」「水を運ぶ男」を意味する。古代エジプトでは、この男が大きな水瓶を水源に投げこみ水をくもうとするため、水があふれ出し、ナイル川で洪水が起こるのだと信じられていた。水瓶座のある秋の夜空には、南の魚座、魚座、鯨座、海豚座、下半身が魚の山羊座など水に関係する星座がずらりと並ぶ。これは、これらの星座の発祥の地である中近東あたりでは、太陽がこの星座の近くを通り過ぎる頃、雨期にあたっていたからだとされている。

フォーマルハウト

魚座は黄道十二星座の第12座。秋の大四辺形の西側に細長いVの字の姿をして横たわっている。星図では2匹の魚がリボンのようなもので結ばれた姿として描かれている。中国では「双魚宮」とよばれていた。ただし、もっとも明るい星でも4等星で、見つけ出すことは簡単ではない。目立った星が存在しないのに、この星座がなにかと話題になるのは、2匹の魚のうち西の魚のしっぽあたりに春分点があるからだ。春分点は太陽の通り道・黄道と天の赤道が交わる点で、春分の日を境に、太陽は南半球から北半球へと移動していく。

# 魚座
*Piscis*

この春分点、時間とともに移動しているので、約600年後には水瓶座に移動することになる。山羊座の森と羊と羊飼いの神パンと同様に、怪物テュフォンに襲われて、あわてて魚に姿を変えて逃げ出しナイル川に飛び込んだ愛と美の女神アフロディテとその息子であるエロスだというギリシア神話が残されている。二人の神ははぐれないようにお互いをひもで結んだのだ。テュフォンは、巨神族を滅ぼされた大地の神ガイアが、復讐のためつかわせた100の頭をもつ怪物である。すさまじい吠え声で神々を恐れさせたという。

春分点

牡羊座は黄道十二星座の第1座。地味な小さな星座だが、約2000年前には、この星座のなかに春分点があったため（現在は魚座に移っている）、黄道十二星座の筆頭として古来より重要視されてきた。地球上の位置を示すのに経度緯度を使うのと同様に、星空の位置を示すのには赤経赤緯を使う。その赤経0度、赤緯0度の点が「春分点」だからである。秋から冬に季節が移りかけているころ、三角座の南に姿を見せる。ギリシア神話では、アタマス王の子プリクソスとヘレーが、継母であるイーノに殺されかけていたところに、大神ゼウスの命をうけて助けにあらわれた羊の姿とされている。イーノは麦の種を火であぶり、大変な凶作を巻きおこす。この凶作をしのぐためには、「アタマス王の二人の子を生贄にしなければならない」と嘘の神託まで用意したのだ。危機一髪のところで二人を助け出したこの羊、金色の毛を持ち、空を飛ぶ。羊の背に乗せられ、北方コルキスに向かう途中、妹のヘレーは目がくらみ海に落ちてしまう。助かった兄のプリクソスは感謝のしるしとして金毛の牡羊をゼウスの神殿に捧げた。ゼウスはこの牡羊を天に召し、星座としたのである。

# 牡羊座
*Aries*

## ケフェウス座
Cepheus

カシオペア座から北極星に至る途中、やや北よりのあたりに淡い光を放つ五つの星が、とんがり屋根をもつ家のカタチをつくっている。この星座のδ星は、5・366日の周期で3・48等級から4・37等級まで規則正しく変更を繰り返す規則変光星である。これを利用することにより、変光星が地球からどれくらい離れたところにあるのか、距離を知ることができるのだ。μ星も変光星で、太陽の直径の1500倍もの大きさの赤色超巨大星として有名である。ケフェウスは古代エチオピア王で、カシオペア王妃の夫であり、アンドロメダ姫の父親である。

## ペガスス座
Pegasus

秋の宵、頭上を見上げると、四つの星が大きな四辺形をつくっっているのが目にとまる。「ペガススの大四辺形」「秋の大四辺形」とよばれるものだ。ペガススの胴体となる部分で、秋の星座探しのための格好の指標となる。日本でも、「四つ星」「桝形星」の名をもつ。ギリシア神話では勇者ペルセウスが、メドゥサの首を切り落としたとき、ほとばしる血が大地にしたたり、そこから銀翼をもつ白馬ペガススが飛び出してきたとされる。以後、ペルセウスの冒険に帯同する。メドゥサの頭髪は蛇で、目は見た者を石に変える魔力をもっていたという。

μ星　σ星

137
136

## 小馬座
*Equuleus*

星図ではペガスス座の鼻先に、馬の顔だけが描かれている。全天で南十字座に次いで2番目に小さな目立たない星座だが、プトレマイオスが設定した48の星座にも選ばれており古い歴史をもつ。淡い光を放つ星々が細長の台形のカタチに並んでいる。かつては海豚座の一部だったものが独立したようだ。ギリシア神話では、商業と伝令の神ヘルメスが、馬術の名手である英雄カストル（双子座）に与えた馬とされている。天馬ペガススの弟馬でセレリスの名をもつ。

## 蜥蜴座
### Lacerta

蜥蜴座は秋、天頂付近で観察できる小さな星座である。アンドロメダ座、白鳥座、ペガスス座、カシオペア座の間の星座のなかった空間に、4等星以下の暗い星をつなげてヘベリウスが新設した。淡いギザギザの星のつながりから蜥蜴の姿を想像するのは容易ではない。ヘベリウスが描いた星図には「トカゲ」とともに「イモリ」とも書かれていて、いずれにせよ、爬虫類のイメージをもっていたのだろう。「フリードリヒの栄誉座」とか「王笏・正義の手座」などの名がつけられたこともあったが、長続きはしなかった。

## 南の魚座
Piscis Austrinus

南の魚座は、秋の宵、南の空の低い位置で見ることができる。水瓶座の水瓶から流れ落ちる水を飲み込む魚の姿をしている。この星座が有する1等星フォーマルハウトの名は、アラビア語の「魚の口」からきている。周辺に明るい星はなく、夜空にポツンと浮かぶこの星には「寂しきもの」「駝鳥」という別名もある。中国では長安の都にあった「北洛師門」の名がつけられていたという。この星座も魚座と同様にテュフォンに襲われて、あわてて魚に変身して逃げ出した愛と美の女神アフロディテの姿だという神話が残されている。

## 三角座
*Triangulum*

アンドロメダ座の足もと、三つの3等星が二等辺三角形のカタチで並んでいる。見た目のとおり、三角座の名がつけられている。古い時代にはデルトトン、Δ座とよばれていたようだ（Δはギリシア文字の4番目デルタの大文字）。小さな星座だが見つけやすく、プトレマイオスの48星座にも選ばれている。エジプトでは「ナイルの家」「ナイル川のデルタ（三角州）」などの名をもつ。中世、キリスト教の時代になると、「神と精霊と人間との調和」を謳った「三位一体」の象徴ともされた。

## 鶴座
### Grus

晩秋、南の魚座のもっと南、地平線ぎりぎりのところに二つの2等星が並んでいるのが観察できる。
ただし、鶴の足のあたりは南天の星座・巨嘴鳥座（きょしちょう）まで達しており日本からその全体像をのぞむことはできない。オランダの航海士たちによって設定されドイツのバイエルの星図に採用されたことで広く知られるようになった。古代エジプトでは、鶴が天体観測のシンボルであったことが命名の理由かもしれない。中世の船乗りたちはこの星座をフラミンゴ座とよんでいたという。

## 彫刻室座
### Sculptor

鯨座の南、東西に長い巨大な星座だが、明るい星はなく、彫刻室をイメージするのはきわめて困難である。星図では脚つきの台の上に胸像、そのそばに鑿（たがね）と槌（つち）が置かれている。フランスの天文学者ラカイユが新設した14の南天の星座の一つだ。ちなみに彼のつけた星座名は「彫刻家のアトリエ」である。日本からだと南よりの地域からしか観測することはできない。もともと星座が設定されていないところに無理矢理つくられたともいえる星座で、南の魚座の1等星フォーマルハウトの東側、夜空の空白部分にあると見当をつけるしかない。

143
142

# 鳳凰座
### Phoenix

鶴座と同様に、オランダの航海士たちによって設定されドイツのバイエルの星図に採用されたことで広く知られるようになった。晩秋、南の空の地平線近く、鶴座と彫刻室座の間で観測することができる。ただし、鹿児島以南からでないと、全体を見ることはできない。一つの2等星と二つの3等星が二等辺三角形をつくる。鳳凰とは古代ギリシアで信じられていた不死鳥（火の鳥）のことである。500年のときを生き、死が訪れるときには自ら炎に飛び込み、再び炎の中から蘇るとされている。

## 顕微鏡座
### Microscopium

射手座の南東、山羊座の南に位置する。地平線の近くに、六つの5等星がコの字に並ぶ。暗い星ばかりで観察はきわめて難しい。星図には長い胴体をもつ古風な顕微鏡が描かれている。顕微鏡は１５９０年、オランダの眼鏡商ヤンセン親子によって発明された。17世紀にはイギリスの科学者ロバート・フックによって現代の顕微鏡に近いものに改良される。ミクロの世界は当時の人たちを大いに魅了した。18世紀、この星座名をつけたラカイユが活躍した時代には顕微鏡の性能は格段に向上し、時代を象徴するハイテク機器となっていたのだろう。

## 炉座
*Fornax*

彫刻室座の東隣に位置する。彫刻室座と同様に日本からだと南よりの地域からでないと観測は難しい。星座を構成する星はすべて4等星以下で目立つことはない。ラカイユが設定した星座はどれも、もともと星座が設定されていなかった空白にも見える夜空に新設したものだからだ。この星座名の炉は、暖房用のものではなく、化学実験用のもので、星図に描かれている炉の上には蒸留器やフラスコのようなものが置かれている。ラカイユの星図が上下さかさまに見えるのは彼が南半球のケープタウンで観測をし、星図を描いたためである。

ドロメダ
ペガスス
かく
うお
つじ
くじら
ろ

W

冬

*Winter*

1/5 = 23:00
1/20 = 22:00
2/5 = 21:00
2/20 = 20:00

牡牛座は黄道十二星座の第2座。オリオン座の西隣、天頂付近で観察できる冬を代表する星座の一つである。日本でも「昴」の名で親しまれるプレアデス星団とオレンジ色の1等星アルデバランを中心としたヒアデス星団、超新星の残骸・カニ星雲M1と見どころ満載だ。「昴」は「統ばる」で、「集まって一つになる」の意味をもつ。ギリシア神話では、大神ゼウスがフェニキア王の娘エウロパ（ヨーロッパの語源）をさらったときに変身した牡牛の姿とされている。エウロパは、突然あらわれた雪のように白く、透きとおるような角をもった美しい牡牛に見とれてし

## 牡牛座
*Taurus*

まう。気を許したエウロパが誘われるままにその背に乗ると、牡牛は海へと走り込み、沖へ沖へと足を進めていく。やがてクレタ島にたどり着いた二人はそこで結ばれるのである。このときの牡牛の姿が星座になったのだ。プレアデス星団にも神話は残されている。天を担ぐアトラスの七人の娘たちを見つけることはできない（日本名では「六連星」ともよばれる）。一つ星が消えてしまったのは、7人娘の一人メローペが人間の妻となったことを恥じたからだと伝えられている。

カニ星雲（M1）

アルデバラン　　ヒアデス星団　　プレアデス星団

オリオン座は全天の88星座の中でもっとも見つけやすい星座といっていいかもしれない。赤い1等星ベテルギウスと青白い1等星リゲルと二つの2等星がつくる四辺形の中に、三つの2等星が整然と並ぶ。日本ではその姿カタチそのままに「鼓星」の名でよばれていた。また、赤いベテルギウスは平家の赤旗になぞらえて「平家星」、青白いリゲルは源氏の白旗とみられ「源氏星」の名を与えられた。昔から世界中の国々で、神、勇者の星座として崇められてきた。ギリシア神話では、巨人オリオンは海神ポセイドンの息子

## オリオン座
*Orion*

で、優れた狩人としてその名を馳せていた。様々な冒険を重ね、クレタ島では月の女神アルテミスと恋に落ちる。そんなある日、狩りの腕前に慢心し横暴をきわめるオリオンに立腹した女神ヘラは、一匹の大サソリ（蠍座）を地上に遣わす。さすがのオリオンもサソリの猛毒にはなすすべもなく、命を落としてしまう。オリオンはその死を悼んだアルテミスのはからいで天に昇り星座となった。オリオンは星座となった今でもサソリのことが恐ろしくてたまらず、蠍座がのぼる時分になると西の空に沈んでいくのだという。

ベテルギウス　γ星

リゲル

153
152

## 双子座
*Gemini*

双子座は黄道十二星座の第3座。ひな祭りの頃、天頂近くに明るい二つの星が仲よく並んで輝く。左側が1等星のポルックス、右側が2等星（正確には1・6等級できわめて1等星に近い）のカストル（六重連星としても有名）だ。日本でも「兄弟星」とよばれることもある。ほかにも「夫婦星」「眼鏡星」「金星銀星」「猫の目」「蟹の目」などの名をもつ。ギリシア神話では、白鳥の姿（白鳥座）に化身した大神ゼウスとスパルタ王妃レダとの間に生まれた双子の弟ポルックスと兄カストルだと伝えられている。ポルックスは神の血を受け継いでおり、拳闘が得意で不死身。カストルは人の血を受け継いでおり、乗馬の名手で戦術家。二人は様々な冒険に出かけ、多くの武勇伝を残す。このため、ローマ時代には船乗りの守り神として崇められた。後に、従兄弟たちとの争いのなかで、カストルが命を落とす。ポルックスは仇を討ち勝利をおさめるが、兄の死が受け入れられない。ポルックスは「不死身の自分に死を賜わり兄とともに過ごすこと」をゼウスに願い出る。ゼウスはその兄弟愛に感じ入り、1日ごとにあの世とこの世で過ごせるようにし、この双子を星座にしたという。

冬の南東の空で燦然と輝く青白い星は、大犬座の1等星シリウス（「焼き焦がすもの」の意）である。明るい星の多い冬の空の中でも、マイナス1・5等級（標準的な1等星の約6倍もの明るさ）のシリウスの明るさは別格といえる。古代エジプトでは夏至の頃、この星が夜明け前の東天にあらわれると、ナイル川の氾濫が始まるとされていた。ここから暑い夏が始まるのである。シリウスを口とした三角形に、鼓型の胴、足と尾もある。かなり明確に犬をイメージすることが可能だ。ギリシア神話では、大犬座についていくつかの話が残されている。一つは狩人オリオン

## 大犬座
### Canis Major

の猟犬。一つはイカリオス王の忠犬メーラ。そして、もう一つは月の女神アルテミスの侍女プロクリスの飼っていた名犬レラプスというもの。レラプスはミノス王から与えられた「獲物を必ず捕まえる犬」である。ある日、国中を荒らしまくる大狐を退治しにプロクリスの夫ケパロスはレラプスを従えて出かける。レラプスは狐を追い続けるものの捕まえることができない。この狐も「絶対捕まらない」という運命を神から与えられていたのだ。この矛盾に困った神は両方を石にしてしまい、犬は天に召し星座にしたという。

シリウス

ε星

## 小犬座
### Canis Minor

小犬座は冬の天の川の東岸に位置する。1等星のプロキオンと3等星のβ星の二つの星で小犬の姿をあらわしている。プロキオンは「犬の前に」の意味で、シリウスより先に東の空からのぼっていくことから名づけられたようだ。シリウスと同様に洪水の季節を予告してくれる大切な星だったのである。プロキオンとシリウス、オリオン座の1等星ベテルギウスを結ぶと「冬の大三角」ができる。冬の夜空を彩る美しい三角形だ。ギリシア神話では、狩りの名人アクタイオン（農芸の神アリスタイオスの子。ケンタウルス族の賢者ケイロンに弓を学ぶ）の猟犬メランポスとされている。ある日、猟に出かけたアクタイオンは森の泉で月の女神アルテミスの水浴びをのぞき見てしまう。誇り高く純潔を旨とするアルテミスは怒りに震え、アクタイオンを鹿の姿に変えてしまう。突然目の前にあらわれた大鹿に猟犬たちは、その鹿が自分たちの主人であることも知らず、いっせいに襲いかかる。アクタイオンは瞬く間に咬み裂かれてしまった。これを哀れに思ったアルテミスによって主人殺しのメランポスは天に召され星座になるのである。

プロキオン

プトレマイオスが設定した48星座の中には、かつてアルゴ船座とよばれる巨大な星座が存在していた。あまりにも大きすぎたので（現在最大の「海蛇座」の1.5倍）、フランスの天文学者ラカイユが、「船尾座」「竜骨座」「羅針盤座」「帆座」の四つに分けたのである。アルゴ船は、イオルクスの王子イアソンが金毛の牡羊（牡羊座）の皮を取り戻すため、コルキスの国に遠征したときの船だ。この船には勇者ヘラクレス、双子の勇士ポルックスとカストル、詩人オルフェウスなど錚々たる顔ぶれが同乗する。一行は数々の苦難に打ち勝ち、つ

## 船尾座（とも）
*Puppis*

いには金毛の牡羊の皮を故郷に持ち帰るのである。日本からはその全体を観察することができない。もともとは一つの星座を四つに分けたものだから、単独の星座としてその姿を夜空に思い浮かべることも難しい。シリウスの東側、天の川が南の地平線に流れ落ちるあたりと見当をつけるしかない。実際、船尾座で注目すべきは、星座のカタチではなく、たくさんの二重星や二重星団とよばれる散開星団M46、M47などである。望遠鏡をのぞけば、それらが次々と視野に飛び込んでくるはずだ。

羅針盤座

船尾座

帆座

竜骨座

M46
M47

## 麒麟座
### Camelopardalis

北極星のすぐそばにある星座で、ほぼ1年中北の空をめぐっている。大きな星座だが明るい星はなく、もっとも目立たない星座の一つといっていいかもしれない。それでも、晩秋から冬にかけてが、一番見つけやすい季節となる。17世紀、ドイツの数学者バルチウスが星図にあらわしてから世に知られるようになった。バルチウスは旧約聖書に出てくるユダヤ人のイサクのもとに美しい妻リベカを運んだラクダからヒントを得、当初「駱駝座」と名づけたようだ。ただし、星図にはキリンが描かれており、結果として「麒麟座」とよばれ続けている。

## 馭者座
### Auriga

牡牛座の角の部分とつながる位置に、五つの明るい星が将棋の駒のようなカタチをつくっている。中国では「五車」、日本では「五つ星」「五角星」の名でよばれている。この星座のα星はカペラ、全天で北極星の一番近くで輝く1等星である。ほぼ1年中北の空でその姿を見ることができるため、多くの地域で最高神の星として崇められていたようだ。ギリシア神話では、この馭者、アテネ王エレクトニウスの姿だとされている。彼は生まれつき足が不自由だったため、戦場に馬車を操ってあらわれ縦横無尽の活躍をしたという。

カペラ

163
162

アケルナル

## エリダヌス座
*Eridanus*

エリダヌスは川の神である。オリオン座の足もと、1等星リゲルあたりを源に、西へ東へと蛇行を繰り返しながら、南の地平線の下まで流れ下っている。川の南の果ては1等星アケルナルなのだが、日本からだと鹿児島以南からでないと見ることができない。面白いことにギリシア以前にもこの星座は川と見られていたようで、エジプトではナイル川、バビロニアではユーフラテス川、ローマではポー川にたとえられていた。ギリシア神話では太陽神アポロンの息子フアエトンが太陽を曳く馬車を操っていたとき、落ちて死んだ川とされている。

## 兎座
*Lepus*

オリオン座の足もとに位置する小さな星座である。三角形の胴体に2本の長い耳をもつ。暗い星ばかりだが意外とその姿はイメージしやすい。プトレマイオスが設定した48星座の一つで、古い歴史をもつのだが、これといった神話は残されていない。この星座が兎座となった理由は、狩人オリオンがもっとも好んだ獲物がウサギだったということだろうか。この星座のR星は血のような赤い色をしていることから、「クリムゾンスター（深紅色星）」とよばれる。蠍座のアンタレスもオリオン座のベテルギウスもこの星の赤さにはおよばない。

## 鳩座
### Columba

鳩座はオリオン座の足もと、兎座の南に位置する小さな星座である。南の地平線近くでしか観察することはできない。鳩座の成立は古く、2世紀のアレクサンドリアの著書にも登場するが、正式には17世紀フランスの天文学者ロワイエの星図によって認められた。この星座名はギリシア神話に由来ではなく、旧約聖書の物語に由来する。嵐に耐え、洪水を乗り切り、アララト山にたどり着いた「ノアの箱舟」から、様子を確かめるために放たれたハトだとされている。7日後ハトはオリーブの枝をくわえ無事戻ってくる。地上の安全が確かめられたのである。

# 一角獣座
*Monoceros*

冬の大三角の間に淡い天の川が流れている。この川の中にひっそりと身を潜めているのが一角獣（ユニコーン）である。明るい星はなく、ほかのヘベリウス新設（ドイツの天文学者バルチウスという説もある）の星座と同様に、そのイメージを夜空に描くことは容易ではない。一角獣は額に長い角を生やしたウマ（一説にはヤギ）で、角には病を治し、毒を消す力があるとされている。一角獣を手に入れると幸運が舞い込むと信じられ、実際多くの人が探し回ったこともあるという。残念ながら、想像上の生物である。

# 彫刻具座
## Caelum

冬の宵、鳩座のすぐ西、南の地平線近くで見える。フランスの天文学者ラカイユが喜望峰でおこなった天体観測をまとめた「南天星座カタログ」の発表の際、新設された南天星座の一つである。ひらがなの「く」の字のカタチに星が並んでいるが、明るい星（すべて5等星以下）はなく探し出すのは難しい。星図では2本のノミ（あるいは鑿）が交差し、リボンのようなもので結ばれている。

## 羅針盤座
*Pyxis*

いくつかの星にもともとアルゴ船座にあった帆柱座を取り込んで、フランスの天文学者ラカイユが羅針盤座を新設した。アルゴ船座の一部というよりは、まったく新しい星座として認識すべきである。

星図に描かれているのは、ギリシア神話の時代には存在していなかった磁気コンパスなのだから。大犬座の南東に位置するが、明るい星も特徴的な星もなく、夜空に羅針盤の姿を思い浮かべるのは困難である。

## 竜骨座
### Carina

竜骨座は南の地平線近くに巨体を横たえるアルゴ船座の中心となる星座である。この星座の1等星（マイナス0・7等級）カノープスは全天でシリウスに次いで2番目に明るい。南天でもっとも美しい星ともいわれている。日本では関東以南で地平線ぎりぎりのところに姿を見せるため、「この星が見えると海が荒れる」と恐れられていたという（地平線に近いと大気の影響で減光されるので、1等星には見えない）。中国では「南極老人星」とよばれ、長寿にあやかれるおめでたい星とされている。日本でも吉兆のしるしと考えられた。

## 帆座
### Vela

帆座は四国以北では全体が観察できない。当然、南半球では帆座全体が空高くそびえ立つ。竜骨座の星とともに美しい十字形をつくるため、南十字星と間違えられることも多い。「にせ十字」とよばれる。にせ十字は南十字よりも大きく、帆座を探すよい目印になる。帆座の見どころは、散光星雲の「ガム星雲」（超新星の爆発によって飛び散った残骸）と惑星状星雲の「南のリング星雲」（琴座のリング星雲に対してこうよぶ）の二つ。

南のリング星雲

ガム星雲

帆座

竜骨座

カノープス

## 時計座
*Horologium*

時計座は炉座、エリダヌス座のさらに南に位置する。日本でこの星座の全体を観察するためには、石垣島あたりまで南下するしかない。フランスの天文学者ラカイユが新設した南天の星座の一つで、星図には大きな振り子時計が描かれている。17世紀、オランダのホイヘンスによって実用化された振り子時計は、当時の天体観測には欠かせない機材（1日で数分しか誤差が生じなかったという）の一つだったのである。ラカイユが喜望峰で南天の空の観測をしたときに持参していたので、これを記念してつけられた名であると想像される。

## 画架座
*Pictor*

画架座は竜骨座の1等星カノープスのすぐ東に位置する。この星座も北海道ではまったく見ることができず、全体を観察するためには石垣島あたりまで南下しなければならない。フランスの天文学者ラカイユが新設した南天の星座の一つで、星図には絵を描くときキャンバスや画板を支えるための台、画架（イーゼル）が描かれている。カタチは3等星のα星を頂点に二つの4等星が足になっており、アルファベットの「V」の字形に並んでいる。比較的、見つけやすい星座かもしれない。

# 南天

*Southern hemisphere*

南天の星座とは、日本
では一部しか見られない
「天の南極」付近の星座

# 南十字座
## Crux

南十字座は南天の夜空でもっとも有名な星座といっていいだろう。二つの1等星アクルックスとベクルックス、一つの2等星、一つの3等星、あわせて四つの星が十字をつくる。全天で一番小さな星座である。ケンタウルス座の南に位置し、日本からでも沖縄あたりまで南下すれば地平線ぎりぎりのところで観察可能だ。紀元前5世紀頃にはヨーロッパ南部からも見えていたようで、ケンタウルス座の一部とされていた時代もある。その後歳差運動によりヨーロッパからはしだいに見えなくなってしまった。それが15世紀、大航海時代に南半球へと遠征した船乗りたちによって再発見されるのである。諸説あるが、独立した星座として星図に描いたのはフランスの天文学者ロワイエが最初のようだ。南天の空には南極星のような星が存在せず、南十字座の位置から天の南極を推定する（十字架の長い辺をおよそ5倍に伸ばしたところ）のが一般的である。南十字座のすぐそばにある暗黒星雲コールサック（石炭袋）も見どころの一つ。南天の天の川にぽっかりと大きな穴があいているように見える。

ガクルックス

ベクルックス

コールサック

アクルックス

アトリア

# 南の三角座
## Triangulum Australe

南の三角座はケンタウルス座のやや南東に位置する。日本からだと沖縄以南からでないと観察は難しい。一つの2等星アトリアと二つの3等星がきれいな三角形をつくる。北の三角座よりはるかに見つけやすい。きわめてわかりやすいカタチなので、南十字座と同様に比較的に早い時期から認識されていたようだ。この星座をはじめて紹介したのは、イタリアの船乗りアメリゴ・ベスプッチとされている。

## コンパス座
*Circinus*

コンパス座は地平線から直立する南天の天の川の中、ケンタウルス座と南の三角座のちょうど中間あたりに位置する。日本からだと石垣島あたりまで南下すれば、やっと地平線ぎりぎりのところで観察できる。フランスの天文学者ラカイユが新設した南天の星座の一つで、明るい星がないため、見つけるのは容易ではない。星図には方位磁石のコンパスではなく、製図用のコンパスが描かれている。

## インディアン座
*Indus*

晩秋から夏にかけて南の地平線上すれすれのところにわずかにその姿を見せる。南北に長い星座だ。沖縄あたりまで南下すれば、弓を構え、矢をつがえたネイティブアメリカンの姿を半分程度は観察できるだろう。星座を構成するのは3等星が一つ、残りは4等星以下の星ばかりで、見つけるのは容易ではない。この星座を設定したのは16世紀の船乗りたちで、17世紀ドイツの天文学者バイアーが星図に記したことで正式に星座として認められた。

## 孔雀座
*Pavo*

孔雀座は射手座のずっと南に位置する。日本では熊本以南からだと星座の一部を見ることができる。頭部に輝く2等星ピーコックを中心に孔雀の姿をイメージしやすい、カタチの整った星の並びとなっている。この星座も設定したのは16世紀の船乗りたちで、17世紀ドイツの天文学者バイアーが星図に記したことで正式に星座として認められた。見どころは球状星団NGC6752と渦巻銀河NGC6872。肉眼でも観察可能な星粒と美しい渦巻の腕は一見の価値ありである。

NGC6752

ピーコック

NGC6872

α星

小マゼラン星雲

# 水蛇座
## Hydrus

水蛇座はエリダヌス座のさらに南に位置する。日本からだと石垣島まで南下しても星座全体を見ることはできない。3等星以下の星ばかりで見つけることは容易ではないが、そばに小マゼラン星雲があり目印となっている。星座の設定者はドイツの天文学者バイアーだが、彼のつけた星座名はHydrus。海蛇座（Hydra）の男性形である。意味をそのままにとれば、牡の海蛇座、小さな海蛇座となる。これを日本では海蛇座との混同を避けるため水蛇座としたのだ。この星座のα星は紀元前3世紀ころには南極星として輝いていた。

## カメレオン座
### Chamaeleon

カメレオン座は天の南極近くに位置するため、日本からはまったく見ることができない。このような星座は全88星座の中にたった四つしかない。全天で10番目に小さな星座である。星座を構成する星は4等星以下だが、細長いレモンの星の並びからカメレオンをイメージすることができるかもしれない。

この星座も設定したのは16世紀の船乗りたちで、17世紀ドイツの天文学者バイアーが星図に記したことで正式に星座として認められることになった。命名の由来は不明である。

## 蠅座(はえ)
### Musca

蠅座は南十字座のすぐ南隣に位置する。水蛇座と同じで、石垣島まで南下しても星座全体を見ることはできない。3等星二つ、4等星三つが歪んだ台形のカタチに並んでいるので、南天の星座の中では見つけやすい星座の一つである。

この星座も設定したのは16世紀の船乗りたちで、17世紀ドイツの天文学者バイアーが星図に記したことで正式に星座として認められた。

ただし、バイアーが星図に記した星座名は蜜蜂座。カメレオンが餌として狙うハエと見立て、最終的にラカイユが蠅座としたのである。

## 飛魚座
*Volans*

飛魚座は竜骨座の南に位置する（1等星カノープスの左下あたり）小さな星座である。日本からだと石垣島まで南下しても星座のほんの一部しか見ることはできない。洋ナシのようなカタチに星は並んでいる。明るい星はないが、「にせ十字」と「大マゼラン銀河」の間にあるので見つけやすいかもしれない。星図ではちょうどアルゴ船（竜骨座）の舷側に翼を広げ飛んでいるトビウオが描かれている。オランダの航海士たちによって設定された南天の12星座の一つである。ほかの星座と同様にドイツの天文学者バイアーが星図に記したことで正式に星座として認められた。

大マゼラン銀河

# 旗魚座
かじき
*Dorado*

旗魚座はエリダヌス座南端のさらに南に位置する。石垣島まで南下すると星座全体の4分の3ほどを観察することができる。この星座を有名にしているのは、なんといっても大マゼラン銀河（マゼランが発見したことから、この名前がつけられたとされる）の存在である。まさに夜空に浮かぶ雲の姿そのもので、フランスのロワイエは当初この星雲に大雲座の名をつけ、星座あつかいにしたくらいだ。この星座も設定したのは16世紀の船乗りたちで、17世紀バイアーが星図に記したことで正式に星座として認められることになった。

## 風鳥座
*Apus*

風鳥座は天の南極と南の三角座の間に位置するため、カメレオン座と同様に日本からはまったく見ることができない。三つの4等星が「く」の字に並ぶ。風鳥とはニューギニア周辺に生息する極楽鳥のことで、大航海時代にはその美しい羽根が珍重され乱獲された。ヨーロッパに入ってきた極楽鳥の足はすべて切断されていたため、「木には止まらずずっと風に乗って飛んでいるのだ」と勘違いされ、この名がつけられたとされる。この星座もバイアーが星図に記したことで正式に星座として認められることになった。

## 八分儀座
Octans

八分儀座はもっとも天の南極の近くに位置する星座である。星座は細長い三角形をしているのだが、明るい星が存在しないため、寂しい印象を受けるかもしれない。したがって南極星にあたる星は存在しない。ちなみにカメレオン座、風鳥座と同様に日本からはまったく観察することのできない四つの星座の一つである。八分儀も六分儀（六分儀座）と同じように天体観測の大切な道具である。ただし六分儀は八分儀を改良したもので、八分儀の方が性能的には劣る。ラカイユが、道具に対する感謝の気持ちから命名したと思われる。

# 巨嘴鳥座
*Tucana*

巨嘴鳥座は天の南極の近く、エリダヌス座の1等星アケルナルと小マゼラン銀河の間に位置する。日本でも奄美大島あたりまで南下すれば、星座の一部を観察することができる。嘴のところに3等星、あとは押しつぶされた五角形のカタチに星が並ぶ。巨嘴鳥は南アメリカの熱帯雨林に生息する鳥で、日本では「おおはし」の名でよばれる、羽の色が鮮やかな美しい鳥である。大航海時代、船乗りたちはこうしたエキゾチックな動物たちをこぞって持ち帰ったのだ。バイアーが設定した南天の12星座中、11星座に動物の名がつけられている。

## レチクル座
*Reticulum*

レチクル座はエリダヌス座の1等星アケルナルと竜骨座の1等星カノープスのほぼ中間に位置する。日本でも石垣島あたりからなら星座全体をのぞむことができる。星たちは小さな菱形をつくって並んでいる。レチクルとは、望遠鏡にとりつける標準（視野に目標となる線を入れる）のこと。望遠鏡、時計、顕微鏡、定規などラカイユお得意のお世話になった道具シリーズの星座名の一つである。ラカイユは菱形のレチクルを愛用していた。比較的カタチのわかりやすい星座で、ラカイユ以前にも菱形を星図に描きこんだ研究者もいたようだ。

## テーブル山座
*Mensa*

テーブル山座は、レチクル座の南、天の南極をはさんで八分儀座とほぼ対称のあたりに位置する。カメレオン座、風鳥座、八分儀座と並んで日本からはまったく見ることのできない四つの星座の一つである。「く」の字のカタチに星は並んでいるのだが、すべて5等星以下で観察は容易ではない。テーブル山（標高1087m）とはラカイユが観測所を設置したケープタウンにある山の名である。頂上が平らでテーブルのような山ということで、この名がつけられている。全天88星座の中で唯一実在の地名が星座名となっている。

宇

*Dictionary*

*of the universe*

星はその明るさに応じて1等星、2等星などに分類される。数字が小さいほど明るい。ただし、その星そのものの明るさをあらわしているのではなく、地球から観測したときの明るさを示している。どれほど明るい星であっても、地球から遠く離れていれば暗く見える（見かけの光度は距離の二乗に反比例して減少する）。逆にそれほど明るくない星であっても、地球に近い星は明るく見える。ちなみに太陽の光度・等級はマイナス26・8等級ということになるが、実際の明るさは2等星の北極星よりもずっと暗い。光度・等級の起源は意外と古く、古代ギリシアの

## 光度・等級
*Luminosity / Magnitude*

天文学者ヒッパルコスがつくったものとされている。彼は夜空に輝く、目立って明るい星20個ほどを1等星とし、肉眼で確認できるぎりぎりの星を6等星と決めた。その中間の明るさの星に2等から5等までの等級をふりあてている。この等級は驚くことに19世紀に至るまで改定されることがなかったが、1830年頃、イギリスの天文学者ハーシェルが数量的に明るさを計算し、客観的な尺度を発表した。等級1段階で明るさが約2・5倍としたのだ。この尺度だと1等星は6等星の約100倍の明るさということになる。

195
194

天文学で用いる長さの単位。光が真空中を1年かかって進む距離を1光年とする。光の速度は毎秒30万km、1年間では約9兆5000億kmになる。太陽と地球との距離は1億5000万kmほど。太陽から出た光はわずか8分18秒ほどで地球に届く。だから、光年という単位を使うのはもっぱら太陽系外の星の話をするときに使うといっていいだろう。太陽系にもっとも近い恒星ケンタウルス座のα星ま

## 光年
*Light-year*

でが4・3光年、大犬座の1等星シリウスまでが8・6光年、銀河系の半径は5万光年となる。太陽系は銀河系の中心から3万光年のところに位置している。銀河系からアンドロメダ銀河までは約230万光年離れている。したがって、今わたしたちが目にしているアンドロメダ銀河は約230万年前に遠い宇宙の果てで放たれた光ということになるのだ。

197/196

## 暗黒エネルギー・暗黒物質
*Dark Energy / Dark Matter*

2003年、NASA（アメリカ航空宇宙局）は、「宇宙の96％は正体不明の物質やエネルギーからできている」と発表（2008年には95％という最新数値を発表）した。宇宙に関してはほとんどなにもわかっていない、といっていいのかもしれない。このわかっていない95％のうちの20％強は暗黒物質（光や電波を出さないので観測はできないが、重さのある物質）、70％強は暗黒エネルギー（全宇宙に満ちている謎のエネルギー、重力とは逆の反発力を周囲におよぼす）だとされている。

199/198

太陽のように、自分自身の内部で大量の熱を発生し光を放つ星を恒星とよぶ。宇宙空間にただようガスや微塵が集まると、万有引力が生じ、大きな塊ができる。その中心部は自らの重力で強く圧縮され高温となる。やがて水素をヘリウムに転化する核融合反応がはじまるのだ。どの恒星も永遠のものではなく、それぞれに寿命がある。

太陽ぐらいの質量の星だと寿命は約100億年。ガスや微塵が円盤状に回転している状態は原始星。核融合がはじまり、熱と光を放ちはじめると主系列星。一生が終わりに近づき大きく赤く輝きはじめ

## 恒星
*Fixed Star*

ると赤色巨星。星をつくっていたガスが外へと流れだすと惑星状星雲。その星の核の部分が残り恒星だった頃の熱で白く輝いているものは白色矮星。冷えて輝きを失うと黒色矮星となる。太陽よりもずっと大きな恒星は、主系列星（高温なので青白く輝く。ただし寿命は100万年程度と短い）から赤色巨星となり、最後は超新星爆発をおこす。爆発後は光さえも抜け出すことのできない、ブラックホールになることもあるが、多くの場合、宇宙をただようガスや微塵となり、新しい星の材料となる。

201/
200

## 惑星
Planet

恒星の重力の影響を受け、そのまわりを回る天体を惑星とよぶ。自ら光を放つことはない。地球も太陽という恒星のまわりを回る惑星の一つである。恒星と比べてきわめて不可解な動きをするため、惑星(プラネット)は「放浪者」の意の名がつけられた。惑星が奇妙な動きをするのは公転速度が地球と他の惑星では異なるためだ。水星、金星は地球をときどき追い越す。逆に火星、木星、土星はときどき地球に追い越される。このため、突然逆方向に動き始めたりするのである。日本では「遊星」、中国では「行星」、とほぼ同義の名をもつ。太陽系には水星、金星、地球、

火星、木星、土星、天王星、海王星の八つの惑星が存在する。地球よりも太陽に近い水星と金星は内惑星とよばれ、見かけ上太陽とあまり離れることがなく、夕刻の西の空、明け方の東の空で観察できる。逆に地球よりも外側にある火星、木星、土星は外惑星とよばれ、太陽と反対の位置にあるときの方が見つけやすい。真夜中に南中するので、ほぼ一晩中観察が可能である。

## 準惑星
*Dwarf Planet*

惑星以外の天体の中でも十分な重さと大きさがあり、ほぼ球体をした天体を準惑星とよぶ。2006年までは第9の惑星と考えられていた冥王星は、月よりも小さく（月の約3分の2程度）、太陽系内に冥王星よりも大きな天体がいくつか発見されたため、準惑星に格下げされた。当初は冥王星よりも大きな小天体を格上げし、惑星を12個とするという提案もされたが、多くの天文学者の反対により却下されたという。

## 衛星
Satellite

惑星の重力の影響を受け、そのまわりを回る天体を衛星とよぶ。月は地球の衛星である。地球以外の惑星も衛星をもつことを最初に発見したのはガリレオである。1610年に木星の四つの衛星（イオ、エウロパ、ガニメデ、カリスト）の観測に成功している。現在、木星の衛星は67個存在することが確認されている。火星には2個（フォボス、デイモス）。土星には65個（ミマス、エンケラドゥスほか）天王星には27個（アリエル、ウンブリエルほか）、海王星には14個（トリトン、ネレイドほか）の衛星が存在する。

## 彗星
Comet

細長い楕円の軌道で太陽のまわりを回っており、長く輝く美しい尾を引く天体を彗星とよぶ。彗星は氷と塵からできた「核」と、電気を帯びたガスでできた青い「イオンの尾」と塵が光ってできた黄色い「塵の尾」でできている。「イオンの尾」は太陽風に流され太陽と反対の方向にまっすぐに伸び、「塵の尾」は太陽からの引力の影響を受け、太く曲ったカタチになる。太陽のまわりを200年未満で回るものは「短周期彗星」（約3年周期のエンケ彗星、76年周期のハレー彗星などが有名）、200年以上かけて回るものは「長周期彗星」とよばれる。短周期彗星は海王星の軌道の外側に広がる「エッジワース・カイパーベルト」から、長周期彗星はそのまだ外側の「オールトの雲」からやってくるとされている。いずれも小惑星や微惑星、氷のカケラが集まった空間である。2013年に太陽に接近したアイソン彗星は大きな話題を集めたが、突然消えてしまった。太陽の熱で核が壊れてしまったと考えられている。逆に2011年に接近したラブジョイ彗星は接近後も消えずに明るい姿を残した。

207
206

## 流星群
*Meteor Shower*

流れ星の正体は実は星ではない。宇宙空間にただよう塵が地球の引力に引き寄せられ、大気にぶつかり明るい光を放ったものだ。この流れ星を1度に数多く見られる現象を流星群とよぶ。流星群は彗星が残した大量の塵がつくった帯に地球が突入したときに発生する。毎年同じ時期に流星群が見られるのはこの塵の帯に突入する時期が同じだからである。流星群は夜空の1点（放射点）から流れるため、流星群の名前は放射点のある星座名でよばれる。水瓶座イータ流星群は4月下旬から5月中旬、ペルセウス座流星群は7月中旬から8月下旬にかけて、オリオン座流星

群は10月、双子座流星群は12月に観測できる。獅子座流星群が33年に1度大出現するのは、この流星群のもととなるテンペル・タットル彗星が33年に1度太陽に近づくからである。

## 星団
*Star Cluster*

多数の恒星が重力的に相互作用して集団を形成しているものを星団とよぶ。星団には散開星団と球状星団の2種類がある。散開星団では数十から1000個程度の恒星がやや不規則に散在する。ガスや塵が集まった星雲から次から次に星が誕生し、時間とともにバラバラになっていったものだ。牡牛座のプレアデス星団（昴）やペルセウス座の二重星団、蠍座のM6、7などが代表例である。球状星団は数万から100万個の恒星が密集したもの。誕生の仕組みは明らかになっていないが、年老いていることが多い。年齢は100億から150億年程度。銀河系の年齢に近い。ヘルクレス座のM13やケンタウルス座のオメガ星団、蠍座のM80などが代表例。

211
210

## 星雲
*Nebula*

星と星の間にあるガスや微塵が集まって、雲のような塊をつくっているものを星雲とよぶ。星雲は惑星状星雲、散光星雲、暗黒星雲の3種類がある。太陽くらいの大きさの恒星の寿命がつきるとき、内部のガスを放出する。そのときにできるのが惑星状星雲である。琴座のM57・リング星雲、蠍座のNGC6302、小狐座のM27・アレイ状星雲などが有名。ちなみに太陽よりもずっと大きな恒星が爆発した後に残る星の残骸は超新星残骸となる。牡牛座のM1・カニ星雲が代表例。散光星雲は地球から見て明るく光っている星雲である。自ら光を放つ輝線星雲と、近くの恒星の光を反射して明るく見える反射星雲の2種にわかれる。オリオン座のM42・オリオン大星雲、カシオペア座のNGC281、白鳥座の北アメリカ星雲、ペリカン星雲、竜骨座のイータカリーナ星雲などが有名。暗黒星雲はガスや微塵が濃く集まって光をさえぎり暗くなっている星雲である。一角獣座のNGC2264・コーン星雲（輝線星雲と暗黒星雲とでできている）、オリオン座の馬頭星雲（1500光年もの大きさをもつ）、南十字座のコールサックなどが代表例。

213
212

数千億個の星、星団、星雲、無数の惑星、大量のガス、塵によって構成される一つの塊を銀河とよぶ。太陽系の存在する銀河系も銀河の一つである。恒星の数は約2000億個。銀河系はバルジ（多くの星が密集している）を中心に円盤が渦を巻いたカタチをしている。有効直径は約10万光年。円盤の中で、明るい星が集まって外に伸びている部分が腕である。ただし、横から見ると中央部分がふくらんだ薄い板のカタチになる。薄い板と平行に夜空を眺めれば無数の星が重なって見える。天の川である。薄い板と垂直に夜空を眺めると星の数は少なくなる。バルジ付近は

## 銀河
*Galaxy*

赤や黄色の年老いた星が多く、周辺には青い若い星が多くなる。銀河系の星はバルジを中心に回っており、中心から2万8000光年の位置にある太陽系も秒速240km、約2億年をかけて1周する。英文では銀河系以外の銀河と区別できるよう、太陽系を含む銀河をGalaxyとGを大文字にして表記する。宇宙には銀河系のほかにも、1000億個を超える銀河が存在している。銀河系と似たようなカタチをした渦巻銀河（アンドロメダ座M31・アンドロメダ銀河、髪の毛座NGC4414など）、渦巻銀河に似ているが中心付近が棒状の棒渦巻銀河（エリダ

ヌス座NGC1300など)、楕円のカタチをした楕円銀河(乙女座M60など)、円盤状でありながら渦巻の目立たないレンズ状銀河(大熊座NGC2787など)、整ったカタチをしていない不規則銀河(大熊座M82、大犬座NGC2207、IC2163など)などに分類される。また、銀河系とアンドロメダ銀河を中心とした半径300万光年の範囲の銀河集団を局部銀河群、50個よりも多い銀河が1000万光年の大きさの範囲に密集しているものを銀河団(乙女座銀河団が有名)とよぶ。

太陽系にもっとも近い銀河である大マゼラン雲まで16万光年、アンドロメダ星雲まで230万光年、もっとも遠い銀河のある銀河団までは100億光年以上の距離がある。

上から見た銀河系

横から見た銀河系

217/216

太陽
Sun

地球にもっとも近い恒星であり、あらゆる生物の生命の源である。その万有引力によって、太陽系に存在するすべての惑星、彗星、小天体などの動きを支配している。およそ46億年前に、銀河系の片隅で誕生した。寿命は100億年ほどとされている。表面温度は6000度。赤道半径で69万4600km、直径で139万2000kmになる。直径は地球の約109倍、質量では33万倍にもなるのだ。現在の自転周期は25・38日だが、誕生直後は活動的で爆発的現象を数多く起こし、自転周期も9日程度だったと考えられている。

219/
218

## 水星
Mercury

太陽のもっとも近くを回っている惑星。直径は4879kmで地球の0・38倍。質量は地球の約0・06倍、重力は約0・4倍。太陽のまわりを公転しており、かなり著しい楕円の軌道を88日かけて1周する。軌道半径の平均は5790万km、天文単位(地球と太陽の距離が1天文単位)で0・39となる。大気がほとんどないため、温度が変化しやすい。昼夜の温度差は600度にもおよぶ(平均表面温度は180度)。自転の周期は58・65日なので、公転周期との組み合わせで一昼夜の長さが176日となる。つまり1日の長さが2公転周期(2年)に相当するという奇妙な世界である。また水星の表面には月の表面と同様に多数のクレーターが存在する。多くのクレーターには著名な芸術家の名がつけられているが、そのうち13個には「紫式部」「清少納言」など、日本人の名がつけられている。地球からは常に太陽の近くに見え、日の出、日の入りの直後のわずかな時間しか観測することができない。このため、ギリシア神話では大神ゼウスの使者で足の速い商業の神ヘルメスになぞらえられた。情報の伝達をつかさどる星とされている。豊富な知識と理論、高い理解力をもつ一方、気苦労が多く神経質な一面をもつ。

221/220

# 金星
Venus

夕方西の空に輝く「宵の明星」、夜明け前は東の空に輝く「明けの明星」として知られる。会合周期は584日。地球との位置関係は8年ごとにほぼ同じになる。軌道半径の平均は1億820万km、天文単位で0.72となる。地球にもっとも接近し、もっとも明るく見える惑星である。最大光度でマイナス4.9等級にもおよぶ(太陽はマイナス26.8等級、月はマイナス12.9等級、火星はマイナス2.5等級、火星と木星はマイナス2.9等級)。中国では「太白」の名でよばれる。直径は1万2104kmで地球の0.95倍。質量は地球の約0.82倍、重力は約0.9倍。公転周期は255日、自転周期(回転方向は地球と逆)は243日である。大気の96％は二酸化炭素で酸素はほとんど存在しない。また、金星を覆う厚い雲の主成分は硫酸である。地表面は高温(平均表面温度は464度)で気圧が高い。惑星の中でももっとも明るく輝く金星はギリシア神話では美と愛の女神アフロディテ(ヴィーナス)にあてはめられる。金星は愛と美と平和をつかさどる星である。洗練された品位、芸術的才能、金銭的な成功が約束される反面、快楽的、刹那的、優柔不断という欠点ももつ。

太陽のまわりを回る惑星の一つである。太陽から約1億4960万kmの平均距離を保つ。誕生したのは約46億年前とされる。赤道半径で6378km、直径は1万2756kmになる。極半径は6357kmだから半径でわずかに20kmしか違わない。地球は楕円体といわれるが、かなり完全な球体に近いのである。質量では木星、土星、海王星、天王星につぐ大きさをもつ。公転周期は365日（正確には365.0073日）、自転周期は1日（正確には0.9973日）である。酸素があり、宇宙線の侵入をくいとめる大気におおわれていることが、生命の繁栄につなが

## 地球
Earth

ったとされる。水星、金星、地球、火星は、水素、ヘリウムなどの軽い元素が少なく地球型惑星とよばれるのに対して、主として水素、ヘリウムからなる木星、土星、天王星、海王星は木星型惑星とよばれる。地球内部には鉄やニッケルを主体とする重い物質が集まって核を、その外側には鉄やマグネシウムなどのケイ酸塩鉱物が集まってマントルがつくられている。

地球のすぐ外側を回っている惑星である。この星が赤く見えるのは地表に赤く錆びた鉄が多く含まれているからと考えられている。かつての火星には大気があったが、その大半は宇宙空間に逃げてしまったようだ。地下には氷の層があり、蒸発した水分によって雲が生じたり、霜が降りたりすることもある。標高2万5000m、火口の直径が70kmにもおよぶオリンポス山が存在する。平均表面温度はマイナス65度。軌道半径の平均は2億2790万kmで、天文単位は1・5237となる。軌道の離心率は水星についで大きいため、地球との距離は大きく変化する。会

## 火星
Mars

合周期は780日だが、大接近は15〜17年ごとに起こる。今後の大接近は2024、39、56、71年となる。赤道半径で3396km、直径は6792kmで地球の0・53倍。質量は地球の約0・11倍、重力は約0・4倍。公転周期は687日、自転周期は1・03日である。フォボス、デイモスという名の、二つの衛星をもつ。中国名は熒惑。ギリシア神話では軍神マルスをあらわす、情熱とエネルギーあふれる活動の惑星である。エネルギッシュで勇気をもっているのでリーダーシップを発揮する一方、軽率で衝動的、粗暴で性急すぎるという欠点ももち合わせている。

227/226

太陽系最大の惑星。地球や火星のように岩石でできた星ではなく、水素とヘリウムのガスが集まった天体（中心部には岩石や氷でできた小さな核が存在する）であるため、はっきりとした地表はないと考えられている。アンモニアなどの粒でできた雲におおわれている。公転周期は11・86年なのに対して、自転周期は0・41日。すごいスピードで回転しているのだ。雲は自転によって流され、木星を観測するとそれがしま模様に見える。赤道半径は7万1492km、直径は14万2984kmで地球の11・21倍。質量は地球の約318倍（体積は1316倍にもなる）、重力は約2・4倍、平均表面温度はマイナス110度。軌道半径の平均は7億7830万kmで、天文単位は5・2となる。ガリレオの発見した四つの衛星イオ、エウロパ、ガニメデ、カリストのほか、全部で67個の衛星をもつ。そのうちの一つ、イオには活火山があることがわかっている。また、エウロパの表面からは水分の噴出が確認されており、生物存在の可能性が高いとされている。ギリシア神話では大神ゼウス（ユピテル、ジュピター）にあてはめられ、幸運と善に満ちた惑星とされる。

## 木星
*Jupiter*

229/228

# 土星
*Saturn*

太陽系では木星につぐ大きさの惑星である。木星同様、水素とヘリウムのガスでできた天体。一番の特徴はまわりを取り巻く巨大な環である。この環の厚みはわずか10mほどで、氷の粒の集まりだと考えられている。環は一見、3本に見えるが実際は無数の細い環の集合体だ。土星は木星の外側をまわっている。軌道半径の平均は14億2940万kmで、天文単位は9・6。肉眼で確測できる、もっとも遠い惑星である。赤道半径は6万268km、直径は12万536kmで地球の9・45倍。質量は地球の約95倍（体積は745倍）。ところが重力は地球よりも小さく約0・

9倍である。内部の温度、圧力も小さく、核部分もかなり小さいことが想像される。平均表面温度はマイナス140度。公転周期は29・46年、自転周期は0・44日。この星もかなり高速で自転しているのだ。衛星数は65個。そのうちの一つ、エンケラドスは表面が氷に覆われており、その割れ目から水が噴き出していることが観測され注目を集めた。この衛星の地下には生命誕生の条件がそろっているからだ。ギリシア神話では遠いところでゆっくり動いている惑星ということで、ゼウスの父、クロノス（サターン）の名が与えられている。

1781年ドイツ出身のイギリスの天文学者ハーシェルによって発見された。極大等級で5．3等級。肉眼でかろうじて確認できる程度の明るさだ。この星は、岩石質の中心核、氷のマントル、水素とヘリウムの上層という3層からできていると考えられている。大気には水素とヘリウムのほか、メタンが多く含まれている。メタンは赤い光を吸収するため、この惑星は青く見えるのだ。土星と同様にいくつかの環ももっている。また、この惑星一番の特徴は公転面に対して横倒しになって自転すること。自転軸がその軌道軸に対して98度

## 天王星
### Uranus

も傾いているのである。直径は5万1118kmで地球の約4倍、質量は約15倍、重力は約0．9倍、平均表面温度はマイナス195度。公転周期は84．02年、自転周期は0．72日。軌道半径の平均は28億7500万km、天文単位は19．2となる。衛星の数は27個。ギリシア神話ではクロノスの父であり、原初の神々の王とされるウラヌスの名がつけられた。天空神である。産業革命の時代に発見されたため、進取の精神をもった星とされている。独創性と創造力にあふれている反面、孤独、流浪、変わり者のイメージをあわせもつ。

233/232

海王星は太陽からもっとも離れたところを回っている惑星である。光度等級は7・8等級で、肉眼での観測は不可能である。天王星の動きはもう一つの未知の惑星による引力の影響がなければ説明できない、ということから研究が始まり、1846年にフランスのルベリエの予測にしたがって観測をおこなったドイツのガレルによって発見された。この星も天王星と同じく、水とメタンとアンモニアの氷からできている。大気には多くのメタンが含まれているため、天王星よりもさらに青く見える。雲の量などが周期的に変化することから、地球と同じように季節のある可能性があると考えられている。直径は4万9528kmで地球の約3・88倍、質量は約17倍、重力は約1・1倍、平均表面温度はマイナス200度。公転周期は166・77年、自転周期は27・32日。軌道半径の平均は45億440万km、天文単位は30・1となる。衛星数は14個。海のような青い色のこの星には、ギリシア神話の海の神ポセイドン（ネプチューン）の名が与えられていて、「霊感」をつかさどる星とされている。鋭敏な知覚をもち、直感力、透視力などに優れる一方、感傷と欺瞞による不安定な一面をもつ。

## 海王星
### Neptune

235/234

月

*Dictionary*

*of the moon*

## 月
### Moon

地球と同じく約46億年前にできたとされる地球の唯一の衛星。半径は1734kmで地球の約0・27倍、質量は0・012倍。大気はほぼ存在せず、重力は約0・17倍。自転しながら地球の周りを公転し、その周期はどちらも27・32日と等しいため、常に一定の反面のみを地球に向けている。太陽との位置関係で新月、上弦、満月、下弦などの満ち欠けを繰り返す。光度等級は満月のときでマイナス12・9等級であり、夜空に浮かぶ天体の中ではもっとも明るい。ギリシア神話では父性の象徴であるとされる太陽に対し、母性の象徴とされる。また、古代から

ロマンチックな存在とされ、繊細で感受性と想像に満ちている反面、気まぐれで移り気な一面をもつといわれる。

## 月面
### Getsumen

月の表面。月面の35％は「海」と呼ばれる玄武岩層で、その他の場所は小石が集まってできた角礫岩で構成される。また、全体がレゴリスと呼ばれる砂で覆われている。1969年7月20日に米国のアポロ11号のニール・アームストロング船長が人類史上初めて月面に降り立った。

## 月の海
### Tsukinoumi

月面にある濃い色の玄武岩で覆われた平原。約40億年前に起こった微惑星の衝突によりできたクレーターを月内部から染み出した玄武岩質溶岩が埋めたものとされる。月面の約35％を占め、地球から見えない裏側にはほとんど存在しない。「海」または「大洋」「湖」「入江」などと呼ばれ、「静かの海」「嵐の大洋」「夢の湖」などがある。また、その模様は「餅をつくウサギ」「ハサミが大きなカニ」「吠えるライオン」など世界各地でさまざまなものにたとえられる。

241/240

## クレーター
### Crater

微惑星や彗星の衝突によってできた主に円形の盆地とそれを取り囲む円環状の山脈で構成された地形。月のクレーターの大部分は、38億年以上前にできたとされる。その多くに「アリストテレス」や「コペルニクス」などの人名がつけられている。

## レゴリス
### Regolith

惑星科学における固体惑星、小惑星、月などの表面を覆う堆積層。月のレゴリスは、岩石の破片や微惑星の衝突爆発によってできたガラス片などであり、月面のほぼすべてを覆っている。

243
242

天球上における月が描く軌道。太陽の天球上の軌道である黄道に対し、およそ5度9分傾いている。黄道と白道の交点である昇交点はおよそ18・6年で黄道を1周してもとにもどる。

## 白道
*Hakudo*

## 恒星月
*Koseigetsu*

月が地球の周りを1周する周期。約27・23日。月の満ち欠けの周期である朔望月が29・53日かかるのは、この間に地球も公転しているため。

# 地球照
### *Chikyusho*

月の欠けた部分が、地球からの反射した太陽光により薄く光って見える現象。新月をまたいだ月齢27から3の程度の月光が少なく、地球からの反射光が多い日に空気の澄んだ暗い場所で見られる。

# 月蝕
*Gesshoku*

地球が太陽と月の間に来ることで月にあたる太陽光が遮られ、月の全部または一部が欠ける現象。

## 日蝕
*Nisshoku*

月が地球と太陽の間に来て太陽光が遮られる現象。太陽面がすべて隠れる現象を皆既日蝕、太陽面が環状にはみ出て隠れる現象を金環日蝕、太陽面が部分的に隠れる現象を部分日蝕という。

## 朔
*Saku*

月と太陽が同じ方向にあり、地球からは見ることができない月。陰暦の1日。月齢は0。

## 朔望
*Sakubo*

月の満ち欠け。地球の周りを公転する月が太陽光に照らされ、反射して輝く部分が変化することで生じるため、地球と月と太陽の位置関係によって決まる。また、朔から望を経て再び朔までの期間を朔望月と呼び、その周期はおよそ29・53日。

## 朔日
*Sakujitsu*

朔の瞬間を含んだ日。陰暦の毎月1日のこと。「ついたち」は「月立ち（つきたち）」が転じた言葉であり、「朔日」「朔」は訓読みで「ついたち」と読む。

## 月齢
*Getsurei*

朔を0として数えた日数。概ね月の満ち欠けに連動するが、月の軌道が楕円で満ち欠けの速度が一定ではないため、必ずしも一致するとはかぎらない。

## 新月
Shingetsu

朔と同義で月と太陽が同一方向にあって地球からは見られない月。月齢は0。また、暦における毎月はじめに見える細い月をさすこともある。また、その細さを女性の眉に喩えて眉月とも呼ばれる。

## 初月
*Hatsuzuki*

新月と同じく、陰暦でその月に最初に見られる月。特に陰暦8月最初に見える月のこと。夕陽を追うようにして、日没直後に沈もうとするさまが見られる。また、三日月をさすこともある。

## 月相
*Gesso*

月の輝く部分が変化するさま。主な月相に新月、上弦、満月、下弦がある。

陰暦の毎月3日目に見える月。月齢は2。このころから月を見ることができるようになる。月の右側が鎌のように細く輝き、日没後に西の空で見ることができる。その形から月の剣ともいわれる。

三日月
Mikazuki

## 繊月
### Sengetsu

糸のように細い月。二日月、三日月など細い月の称。

## 上弦の月
*Jogennotsuki*

新月から満月になる間の半月。月齢は6。日没の夕方に南の空で左半分欠けた状態で輝きはじめる。その後、西に進むにつれて右に傾きながら深夜に沈む。輝いている間のさまが上方に弦を張った弓のように見えることから名づけられた。上つ弓張、上の弓張ともいう。

## 弓張月
*Yumiharitsuki*

上弦、下弦の月の総称。月の形が弦を張った弓に見えることから呼ばれる。その他の呼称として弦月、弓を引くということから彎月とも。

257/256

## 十日夜
*Tokanya*

陰暦10月10日の夜。またその夜に主に東日本で行われる収穫祭。十五夜と同じくお供え物をすることもある。刈上げ十日ともいわれ、稲の刈り入れが終わって田の神が山に帰る日とされる。西日本では陰暦10月の亥の日に「亥の子」と呼ばれる刈上げ行事が行われる。

## 十三夜
*Jusanya*

陰暦の毎月13日の夜のこと。特に9月13日の夜をさす。十三夜の月は満月に次いで美しいとされる。8月の十五夜に対して後の月、芋名月に対して豆名月、栗名月と呼ばれ、各地で月見や収穫祭が行われる。

## 待宵月
### Matsuyoizuki

陰暦の毎月14日の月。特に8月14日の月をさす。月齢は13。月見が現在より庶民の楽しみとして盛んだったころ、翌日の名月が楽しみに待たれたことからいわれる。小望月ともいう。

# 十五夜
*Jugoya*

陰暦の毎月15日の夜のこと。特に8月15日の夜をさす。陰暦8月は秋の最中にあたることから仲秋といい、この日の月を仲秋の名月と呼ぶ。また収穫期である芋を供えることから芋名月ともいわれる。古くから観月の好時節とされ、各地で月見の宴が催されてきた。3と5の積が15になることから三五とも。

## 虧月
### Kigetsu

満月から新月にむかって次第に欠けていく月。

## 無月
### Mugetsu

仲秋の夜に雲などで月が見えないこと。

## 盈月
### Eigetsu

新月から満月にむかって次第に円くなっていく月。

## 雨月
### Ugetsu

仲秋の夜に雨が降って月が見えないこと。

## 満月
*Mangetsu*

月、地球、太陽の順に直線に並ぶことで、地球から見える月の全面に太陽光があたり、円く輝いて見える月のこと。月齢は14。特に8月の満月は名月とされ賞される。日没とともに東の空から昇り、深夜に南の空へ進み、日の出とともに西の空へ沈んでいく。望、望月、天満月ともいう。

曇りなく澄みきった満月のこと。
名月。

明月
*Meigetsu*

月天心
*Tsukitenshin*

高度が高く、天の中心を通る冬の満月のこと。北半球の中緯度にある日本では、月の高度は冬にもっとも高くなる。

## 十六夜
*Izayoi*

陰暦の毎月16日の夜のこと。月齢は15。十五夜より月が50分ほど遅れて、いざよい（ためらい）ながら昇るさまから呼ばれる。また、すでに望が終わったという意味で既望とも。

## 更待月
*Fukemachizuki*

陰暦の毎月20日の月。二十日月とも。月齢は19。月が出るのが、夜更けごろであるため呼ばれる。また、亥の刻に月が出るため、亥中の月ともいわれる。

## 下弦の月
*Kagennotsuki*

満月から新月になる間の半月。月齢は22。深夜に東から右上半分が欠けた状態で昇りはじめ、右に傾きながら、日の出ごろに南の空へ昇る。上弦の月とは違い、輝いている間は下方に弦を張った形にはならないが入りにあたって弦が下方になる。

## 二十三夜待ち
*Nijusanyamachi*

陰暦の23日の夜半過ぎに昇る月を待つこと。月待ちをすることで願いが叶う、病気にならないなど吉兆があるといわれる。この日は月が0時ごろに出るため、真夜中の月ともいう。

## 二十六夜
*Nijurokuya*

陰暦の26日に出る月のこと。明け方である暁、有明の空に残っていることから、暁月、有明の月、残月ともいい、これらは十六夜以降の月の総称でもある。

月光
*Gekko*

月の光のこと。月の光は月そのものが輝いているわけではなく、太陽に照らされた反射光である。月華、月明とも。

## 月前
*Getsuzen*

月の光が照らす範囲。また、他の勢力におされて影の薄い存在になったことのたとえ。

## 月影
*Tsukikage*

月、または月の光のこと。月の形や姿、月の光でできた影をさすこともある。

## 朧月
*Oborozuki*

霧や靄などに隠れて、ほのかに霞んで見える月のこと。また、朧月の光がほのかに射す夜のことを朧月夜という。

薄い雲に遮られ、はっきり見えない月のこと。また、薄月の柔らかい光が射す夜のことを薄月夜という。

薄月
Usuzuki

## 月暈
*Getsuun*

薄い雲がかかった際に月の周りに光の輪が見える現象。薄い雲がかかった際に、雲を形成する氷晶がプリズムとして光を屈折することで発生する。太陽でも「日暈」と呼ばれる同様の現象が起こる。太陽では光が強く、虹のような色を確認できるが、月暈は色彩が弱く、肉眼では白く見える。

## 水月
*Suigetsu*

水面に映った月のこと。また、実体のないもののたとえ。同様に、鏡に映った花や水に映った月のように目に見えても手にできないことを「鏡花水月」という。

## 寒月
### Kangetsu

寒々として冴えわたった冬の月のこと。白く輝く月の光が寒さをより強調することから。

## 雪待月
### Yukimachizuki

雪が降り出しそうな空に出ている月のこと。また、陰暦の11月のこと。

277/276

佳月
*Kagetsu*

美しい月、名月のこと。

# 皓月
*Kogetsu*

明るく輝く月。明月、名月。

星はとてつもなく美しい。星を美しいと感じる知的生命体は、地球以外にも存在するのか。誰もが一度は考えたことがあるに違いない。

銀河系（太陽系の存在する）だけでも、およそ2000億個の恒星が存在する。そして宇宙にはこの銀河が1000億個以上も存在するのである。地球と同じような環境を持った惑星はそれこそ無限に存在するのではないか、誰しもが考えるだろう。

ところが、この知的生命体の存在する惑星の条件は想像以上に厳しいものだ。

まず、基本条件として「液体としての水」が必要だと考えられる。もちろん単なる生命体であれば、液体メタン（土星の衛星タイタンには液体メタンの川

## Afterword

や湖がある）で誕生する可能性も否定できないのだが、この生命体が知的生命体に進化していく可能性は低い。

「水」が存在する範囲のことを「ハビタブルゾーン」（生命居住可能領域）とよぶ。太陽系であれば、地球の軌道の少し内側から火星の軌道あたりまでである。ただ、火星には「液体としての水」は存在しない。火星の重力は地球の10分の1しかなく、大気を保持できないのである。気圧が低ければ水は低温で気体に変わる。かつて存在したとされる火星の水はすべて蒸発してしまったのだ。月も同様である。金星は地球とほぼ同じサイズだが、軌道が太陽に近すぎる。表面温度が高くなり、水はすべて蒸発してしまう。木星、土星では

太陽から遠すぎるため通常水は凍ってしまう。木星や土星の衛星に水が存在するのは大きな重力「潮汐力」が衛星を揺り動かしているからだ。

惑星の自転スピードも重要である。自転しないというのは問題外としても、遅すぎても速すぎても、生命の維持は難しい。地球の24時間に1回転という自転速度は絶妙なのだ。

恒星の大きさも重要である。太陽よりも巨大な星は寿命がずっと短くなってしまうからだ。知的生命体の誕生までには数十億年のときが必要だと考えられている。だとすれば、たとえ生命が誕生したとしても、その生命が高等生物に進化する前に巨大な恒星は燃え尽きてしまう可能性大なのである。

他にも地球はたくさんの幸運に助けられている。例えば、木星という巨大惑星が存在しなかったら、地球には相当数の小惑星が衝突していたはずだとか、月が存在しなかったら、地軸の傾きが大きく変化し、気候変動が激しくなっていたとか。地球が奇跡の星であるとよばれるのは、それなりに理由があってのことなのだ。

それでも、最近は宇宙観測技術の進歩により、地球の環境に近い惑星がぞくぞくと発見されている。われわれとは別の惑星の上に立ち、同じように美しい星々に心をふるわせている知的生命体が必ずや存在するはずだ。

きっと今夜も星々は美しく、神秘的であるに違いない。

柳谷杞一郎

| 〈も〉 | 木星（もくせい） | 228 |
| --- | --- | --- |
| | 望月（もちづき） | 263 |
| 〈や〉 | 山羊座（やぎざ） | 128 |
| | 矢座（やざ） | 110 |
| | 山猫座（やまねこざ） | 82 |
| 〈ゆ〉 | 雪待月（ゆきまちづき） | 276 |
| | 弓張月（ゆみはりづき） | 256 |
| 〈ら〉 | 羅針盤座（らしんばんざ） | 169 |
| 〈り〉 | リゲル（りげる） | 38 |
| | リゲル・ケンタウルス | |
| | （りげる・けんたうるす） | 40 |
| | 竜骨座（りゅうこつざ） | 170 |
| | 竜座（りゅうざ） | 108 |
| | 流星群（りゅうせいぐん） | 208 |
| | 猟犬座（りょうけんざ） | 74 |
| 〈れ〉 | レグルス（れぐるす） | 49 |
| | レゴリス（れごりす） | 242 |
| | レチクル座（れちくるざ） | 190 |
| 〈ろ〉 | 六分儀座（ろくぶんぎざ） | 84 |
| | 炉座（ろざ） | 146 |
| 〈わ〉 | 惑星（わくせい） | 202 |
| | 鷲座（わしざ） | 102 |
| | 彎月（わんげつ） | 256 |

# Index

| | | |
|---|---|---|
| つ | 月（つき） | 238 |
| | 月影（つきかげ） | 271 |
| | 月天心（つきてんしん） | 265 |
| | 月の海（つきのうみ） | 240 |
| | 鶴座（つるざ） | 142 |
| て | デネブ（でねぶ） | 48 |
| | テーブル山座（てーぶるさんざ） | 191 |
| | 天秤座（てんびんざ） | 94 |
| | 天王星（てんのうせい） | 232 |
| と | 等級（とうきゅう） | 194 |
| | 十日夜（とおかんや） | 258 |
| | 蜥蜴座（とかげざ） | 139 |
| | 時計座（とけいざ） | 172 |
| | 土星（どせい） | 230 |
| | 飛魚座（とびうおざ） | 185 |
| | 船尾座（ともざ） | 160 |
| に | 二十三夜待ち（にじゅうさんやまち） | 267 |
| | 二十六夜（にじゅうろくや） | 268 |
| | 日蝕（にっしょく） | 249 |
| は | 蠅座（はえざ） | 184 |
| | 白鳥座（はくちょうざ） | 104 |
| | 白道（はくどう） | 244 |
| | ハダル（はだる） | 41 |
| | 八分儀座（はちぶんぎざ） | 188 |
| | 初月（はつづき） | 253 |
| | 二十日月（はつかづき） | 266 |
| | 鳩座（はとざ） | 166 |
| ふ | 風鳥座（ふうちょうざ） | 187 |
| | フォーマルハウト（ふぉーまるはうと） | 52 |
| | 更待月（ふけまちづき） | 266 |
| | 双子座（ふたござ） | 154 |
| | 二日月（ふつかづき） | 255 |
| | 部分日蝕（ぶぶんにっしょく） | 249 |
| | プロキオン（ぷろきおん） | 37 |
| へ | ベガ（べが） | 42 |
| | ペガスス座（ぺがすすざ） | 136 |
| | ベクルックス（べくるっくす） | 46 |
| | ベテルギウス（べてるぎうす） | 38 |
| | 蛇座（へびざ） | 111 |
| | 蛇遣座（へびつかいざ） | 106 |
| | ヘルクルス座（へるくるすざ） | 98 |
| | ペルセウス座（ぺるせうすざ） | 124 |
| ほ | 望（ぼう） | 263 |
| | 望遠鏡座（ぼうえんきょうざ） | 117 |
| | 鳳凰座（ほうおうざ） | 144 |
| | 帆座（ほざ） | 170 |
| | ポラリス（ぽらりす） | 50 |
| | ポルックス（ぽるっくす） | 54 |
| | ポンプ座（ぽんぷざ） | 85 |
| ま | 待宵月（まつよいづき） | 259 |
| | 眉月（まゆつき） | 252 |
| | 真夜中の月（まよなかのつき） | 267 |
| | 満月（まんげつ） | 263 |
| み | 三日月（みかづき） | 254 |
| | 水瓶座（みずがめざ） | 130 |
| | 水蛇座（みずへびざ） | 182 |
| | 南十字座（みなみじゅうじざ） | 176 |
| | 南の魚座（みなみのうおざ） | 140 |
| | 南の冠座（みなみのかんむりざ） | 114 |
| | 南の三角座（みなみのさんかくざ） | 178 |
| | ミラ（みら） | 53 |
| む | 無月（むげつ） | 262 |
| め | 明月（めいげつ） | 264 |

| | | |
|---|---|---|
| 巨嘴鳥座（きょしちょうざ） | 189 |
| 馭者座（ぎょしゃざ） | 162 |
| 銀河（ぎんが） | 214 |
| 金環日蝕（きんかんにっしょく） | 249 |
| 金星（きんせい） | 222 |
| 孔雀座（くじゃくざ） | 180 |
| 鯨座（くじらざ） | 126 |
| クレーター（くれーたー） | 242 |
| 月暈（げつうん） | 274 |
| 月華（げっか） | 270 |
| 月光（げっこう） | 270 |
| 月蝕（げっしょく） | 247 |
| 月前（げつぜん） | 271 |
| 月相（げっそう） | 253 |
| 月明（げつめい） | 270 |
| 月面（げつめん） | 240 |
| 月齢（げつれい） | 251 |
| ケフェウス座（けふぇうすざ） | 136 |
| ケンタウルス座（けんたうるすざ） | 80 |
| 顕微鏡座（けんびきょうざ） | 145 |
| 小犬座（こいぬざ） | 158 |
| 皓月（こうげつ） | 279 |
| 恒星（こうせい） | 200 |
| 恒星月（こうせいげつ） | 245 |
| 光度（こうど） | 194 |
| 光年（こうねん） | 196 |
| 小馬座（こうまざ） | 138 |
| 小狐座（こぎつねざ） | 108 |
| 小熊座（こぐまざ） | 60 |
| 小獅子座（こじしざ） | 83 |
| コップ座（こっぷざ） | 68 |
| 琴座（ことざ） | 100 |
| 小望月（こもちづき） | 259 |

| | | |
|---|---|---|
| コンパス座（こんぱすざ） | 179 |
| 祭壇座（さいだんざ） | 116 |
| 朔（さく） | 250 |
| 朔日（さくじつ） | 251 |
| 朔望（さくぼう） | 250 |
| 蠍座（さそりざ） | 90 |
| 三角座（さんかくざ） | 141 |
| 三五（さんご） | 261 |
| 残月（ざんげつ） | 268 |
| 獅子座（ししざ） | 64 |
| 十五夜（じゅうごや） | 261 |
| 十三夜（じゅうさんや） | 258 |
| 準惑星（じゅんわくせい） | 204 |
| 定規座（じょうぎざ） | 115 |
| 上弦の月（じょうげんのつき） | 256 |
| シリウス（しりうす） | 32 |
| 新月（しんげつ） | 252 |
| 水月（すいげつ） | 275 |
| 水星（すいせい） | 220 |
| 彗星（すいせい） | 206 |
| スピカ（すぴか） | 41 |
| 星雲（せいうん） | 212 |
| 星団（せいだん） | 210 |
| 繊月（せんげつ） | 255 |
| 太陽（たいよう） | 218 |
| 楯座（たてざ） | 113 |
| 地球（ちきゅう） | 224 |
| 地球照（ちきゅうしょう） | 246 |
| 仲秋（ちゅうしゅう） | 261 |
| 仲秋の名月<br>（ちゅうしゅうのめいげつ） | 261 |
| 彫刻具座（ちょうこくぐざ） | 168 |
| 彫刻室座（ちょうこくしつざ） | 142 |

# Index

## あ
- アクルックス（あくるっくす） 46
- アケルナル（あけるなる） 40
- 天満月（あまみつつき） 263
- 有明の月（ありあけのつき） 268
- アルクトゥルス（あるくとぅるす） 34
- アルタイル（あるたいる） 43
- アルデバラン（あるでばらん） 44
- 暗黒エネルギー（あんこくえねるぎー） 198
- 暗黒物質（あんこくぶっしつ） 198
- アンタレス（あんたれす） 45
- アンドロメダ座（あんどろめだざ） 122

## い
- 十六夜（いざよい） 266
- 一角獣座（いっかくじゅうざ） 167
- 射手座（いてざ） 92
- 亥中の月（いなかのつき） 266
- 芋名月（いもめいげつ） 261

## う
- 海豚座（いるかざ） 112
- インディアン座（いんでぃあんざ） 180
- 魚座（うおざ） 132
- 雨月（うげつ） 262
- 兎座（うさぎざ） 165
- 牛飼座（うしかいざ） 72
- 薄月（うすづき） 273
- 薄月夜（うすづきよ） 273
- 海蛇座（うみへびざ） 66

## え
- 盈月（えいげつ） 262
- 衛星（えいせい） 205
- エリダヌス座（えりだぬすざ） 164

## お
- 牡牛座（おうしざ） 150
- 大犬座（おおいぬざ） 156
- 大犬座ε星（おおいぬざいぷしろんせい） 52
- 狼座（おおかみざ） 86
- 大熊座（おおくまざ） 58
- 乙女座（おとめざ） 78
- 牡羊座（おひつじざ） 134
- オリオン座（おりおんざ） 152
- オリオン座γ星（おりおんざがんませい） 53
- 朧月（おぼろづき） 272
- 朧月夜（おぼろづきよ） 272

## か
- 海王星（かいおうせい） 234
- 皆既日蝕（かいきにっしょく） 249
- 画架座（がかざ） 173
- ガクルックス（がくるっくす） 47
- 佳月（かげつ） 278
- 下弦の月（かげんのつき） 267
- カシオペア座（かしおぺあざ） 120
- 旗魚座（かじきざ） 186
- カストル（かすとる） 54
- 火星（かせい） 226
- 蟹座（かにざ） 62
- カノープス（かのーぷす） 32
- カペラ（かぺら） 36
- 上つ弓張（かみつゆみはり） 256
- 髪の毛座（かみのけざ） 76
- 上の弓張（かみのゆみはり） 256
- カメレオン座（かめれおんざ） 183
- 烏座（からすざ） 70
- 寒月（かんげつ） 276
- 冠座（かんむりざ） 96

## き
- 虧月（きげつ） 262
- 既望（きぼう） 266
- 麒麟座（きりんざ） 162
- 暁月（ぎょうげつ） 268

285 / 284

## Reference

- 「理科年表2016」国立天文台編／丸善出版
- 「天文年鑑2016」天文年鑑編集委員会編／誠文堂新光社
- 「日本大百科全書」小学館
- 「全天星座百科」藤井旭著／河出書房新社
- 「星座の事典」沼澤茂美・脇屋奈々代著／ナツメ社
- 「星空の神々」長島晶裕・ORG著／新紀元社
- 「星をさがす本」林完次著／角川書店
- 「眠れなくなる宇宙の話」佐藤勝彦著／宝島社
- 「ますます眠れなくなる宇宙の話」佐藤勝彦著／宝島社
- 「大人も子どもも夢中になる はじめての宇宙の話」佐藤勝彦著／かんき出版
- 「星座と神話がわかる本」宇宙科学研究倶楽部編／学研パブリッシング
- 「星座を見つけよう」H.A.レイ著・草下英明訳／福音館
- 「講談社の動く図鑑MOVE 星と星座」渡部潤一監修／講談社
- 「ギリシア神話を知っていますか」阿刀田高著／新潮社
- 「私のギリシャ神話」阿刀田高著／NHK出版
- 「図解雑学ギリシャ神話」豊田和二監修／ナツメ社
- 「星と星座の見方がわかる本」縣秀彦著／学研パブリッシング
- 「星の文化史事典」出雲晶子編著／白水社
- 「宙の名前」林完次著／KADOKAWA
- 「夜空と星の物語」PIE BOOKS制作／パイインターナショナル
- 「恒星と惑星」アンドリュー・K・ジョンストン監修・後藤真理子訳／科学同人

## Credit

- 写真提供＝NASA
  P202-203／P204／P211／P218-219／P229／P230-231／P233／P235
- 星図＝星降る（hoshifuru.jp）※一部をアレンジしています
  P56-57／P88-89／P118-119／P148-149

星の辞典

2016年11月29日 初版第1刷発行
2024年7月17日 第12刷発行

著者 = 柳谷杞一郎
デザイン・イラスト = 林 真（vond°）
執筆（月の章）= 中村 徹
編集 = 益田 光
写真 = PIXTA
発行者 = 安在美佐緒
発行所 = 雷鳥社

〒167-0043 東京都杉並区上荻2-4-12
TEL 03-5303-9766
FAX 03-5303-9567
HP http://www.raichosha.co.jp/
E-mail info@raichosha.co.jp
郵便振替 00110-9-97086

印刷・製本 = シナノ印刷株式会社

定価はカバーに表示してあります。
本書の写真や記事の無断転写・複写をお断りいたします。
著者権者、出版者の権利侵害となります。
万一、乱丁・落丁がありました場合はお取替えいたします。

©Kiichiro Yanagitani / Raichosha 2016
Printed in Japan
ISBN978-4-8441-3703-0 C0072

---

柳谷杞一郎　Yanagitani Kiichiro

写真家・編集者。1957年広島生まれ。修道学園中・高等部、慶應義塾大学文学部卒。「エスクァイア日本版」副編集長を経てフリーに。写真でわかる謎への旅シリーズ「イースター島」「マチュピチュ」、「大事なことはみんなリクルートから教わった」「ぼくたちの論語」など著書多数。